Katrinaville Chronicles

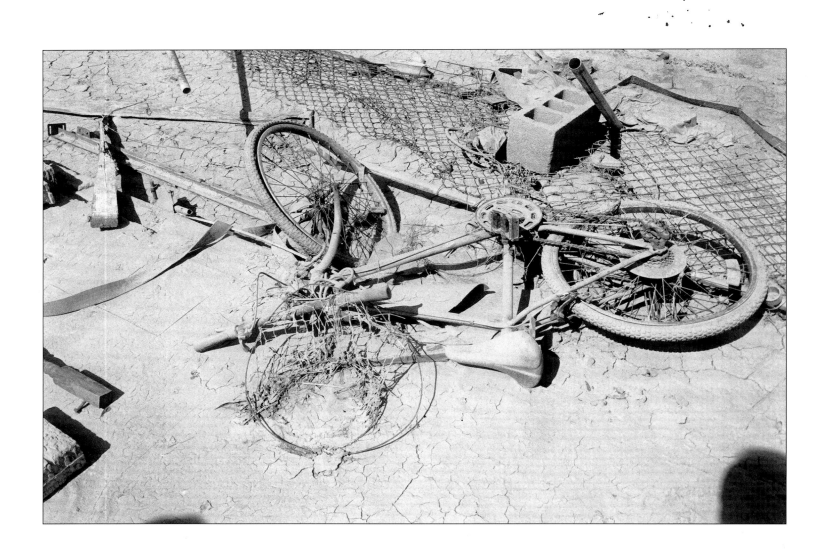

For Billy & Sally
Thanks for your interest!
All the Best
[signature]
Day 574

Katrinaville Chronicles

Images and Observations from a New Orleans Photographer

DAVID G. SPIELMAN

[signature]

LOUISIANA STATE UNIVERSITY PRESS

BATON ROUGE

Published by Louisiana State University Press
Copyright © 2007 by David G. Spielman
All rights reserved
Manufactured in Canada
First printing

Designer: Laura Gleason
Typeface: Minion
Printer and binder: Friesens through Four Colour Imports, Ltd.

Library of Congress Cataloging-in-Publication Data

Spielman, David G., 1950–
 Katrinaville chronicles : images and observations from a New Orleans
photographer / David G. Spielman.
 p. cm.
 ISBN-13: 978-0-8071-3252-4 (cloth : alk. paper)
1. New Orleans (La.)—Pictorial works. 2. Hurricane Katrina, 2005—
Pictorial works. 3. New Orleans (La.)—Social conditions—Pictorial
works. 4. New Orleans (La.)—Description and travel. 5. New Orleans
(La.)—Social conditions. 6. Spielman, David G., 1950– —Correspondence.
7. Photographers—Louisiana—New Orleans—Correspondence. I. Title.
 F379.N543S68 2007
 976.3'35—dc22
 2006030166

The paper in this book meets the guidelines for permanence and durability
of the Committee on Production Guidelines for Book Longevity of the
Council on Library Resources. ∞

Contents

Acknowledgments

I never intended or believed that my e-mails would be worth remembering, but they were passed on and forwarded to whom and where I don't know. Three wonderful writers individually and collectively suggested and encouraged me to pursue the publication of my images and e-mails. Sonny Brewer, Rick Bragg, and Doug Brinkley, thanks for being kind and supportive. It is very clear that their future isn't threatened by my prose. Terry Hall was another who was convinced that I needed to and should do a book. His generous gift helped fund production of this book.

I wish now I had kept or noted all the e-mails and phone calls of encouragement and good wishes, because I have so many people to thank and some of the names escape me. Please know that I counted on them all during the tough and dark times.

To everyone who helped me gather information around town, thank you. Especially Dr. Brobson Lutz, who helped me with not only information but a very much needed supply of gas. All of you others who shared with me, thank you!

Katrinaville Chronicles

Introduction

It all started as it had so many times before. A hurricane in the gulf, the warnings, the rushing about, getting ready, wondering if this time it was going to hit. I wasn't going to leave. I haven't in the past; I live in Uptown New Orleans, close to the river, some of the highest ground around. I shuttered my house, gathered supplies: peanut butter, bread, water, and candles. My girlfriend and her son, Shelley and Sasha, were going to stay. At the last minute her parents decided to leave, wanting Shelley and Sasha to go with them. Her father had been through many hurricanes and felt that this time they needed to go. Early, very early Sunday morning, we said our good-byes, still clueless as to what was about to happen to us.

My attention and energies turned to helping my longtime friends the Poor Clare nuns ready themselves to weather the storm. They don't leave. Their one-hundred-year-plus presence here has been continuous. My task was to help board up the uppermost windows in their three-story brick building, just two and a half blocks from my house. There was an air of excitement, but not much worry. As a matter of fact, I felt that this storm was a bother and major inconvenience, interfering with my life and work. So I really wanted it to be over and done with as quickly as possible. I never realized what was in store for all of us.

Early Monday morning, August 29, Katrina came ashore. The winds blew. The one-hundred-year-old building shook, shutters rattled. Looking out into the yard as best we could, we saw the trees were bent, twisting and turning. Then with a pop that sounded like a gun, large limbs would blow to the ground. Losing power at 4:45 A.M. we knew the storm had arrived and would be playing itself out over the next several hours.

By midafternoon the rains slowed and the clouds started to break. The sisters opened their front door to have a first-hand look outside. The convent takes up one city block with large walls surrounding the place, so our field of view was pretty limited. Walking out and looking around the grounds, we saw significant tree and limb damage. Debris everywhere. We could see lots of roof damage on the surrounding houses, but the convent's had survived unharmed.

What to do next? Communications were gone. Radio and TV were knocked off the air; cell phones didn't work. So I decided to put on my running gear and go out for my run and see what there was to see. This was easier said than done as the streets were blocked with downed power lines and trees and limbs. I headed over to check on Shelley's house and then on to her parents' place. Just a couple of miles in total, a short run normally, but with the debris it took hours to make my way.

Returning to the monastery, I reported that Uptown was a mess. Streets were impassable, lots of roofs were damaged, but we had survived. All we had to do was wait and soon the streets would be cleared and the electricity and phone services would be restored. As I was relating this to the sisters, none of us was aware of the damage to the levees and that the flooding of the city was starting.

I was coming to the conclusion that Katrina wasn't going to offer me any worthwhile images. I am a freelance photographer and not being a hard-news guy, I hadn't seen anything so far that was going to win any awards. So this was going to be a real drag, stuck and without any possible images to capture. What was I going to do?

Tuesday's run changed some of that. The waters were rising. Heading to Shelley's parents' house in the bowl of Broadmoor, I ran past Memorial Medical Center. At this point it wasn't flooded. I heard gunshots on St. Charles Avenue and saw young men out scouting. Clearly they weren't out, like me, getting their exercise but were looking for opportunities. I hadn't seen the police stopping and talking with others. It was becoming obvious things were changing and changing fast. Reports of the levees failing and of massive flooding were spreading. The lack of police protection was also noticed and mentioned by most of the people I spoke with. I still didn't have a clue as to what was going on at the Superdome or, later, what would be happening at the convention center.

Reporting all this to the sisters, I could see the concern growing on their faces. Their response, of course, was more prayers and confidence that help was just around the corner. Wednesday's run provided me with more dark and disturbing examples that the city was slipping into chaos. Returning and wanting to bathe, I discovered that we were without water. In the course of an hour or so, we had lost water pressure. Without electricity and phone service things were bad, but without water and with anarchy at hand, things went to worse.

Leaving the monastery and heading to my gallery, I saw much more looting, gangs roaming, looking for whatever they were looking for. Inspecting The Rink, in which my gallery is located, I saw it had survived extremely well. A former skating rink over a hundred years old, it houses several shops

and offices and has raised glass skylights, none of which was broken. Very lucky indeed. As I was inspecting my space, I heard loud banging and a crashing noise. Startled and scared, I sneaked a peek. There were five young men trying to break into the building. Just what I didn't want to see or be part of, but what was I going to do? I had brought a gun, and I knew I needed to try to run them off. Once they got in the building, my options would be few and things might get very messy. So I walked to the top of the steps inside the front entrance and shouted at them. Pointing at the gun in my hand, I told them I was here and they had better go. After a long moment of them looking at me, they left.

Moving back Uptown, returning to the monastery, I realized that the last several days didn't bode well for the future or the sisters. Extreme heat, no power, no phone, and no water. Lawlessness was becoming the order of the day. The abbess asked me to present my observations to the rest of the nuns at their house meeting scheduled for later in the afternoon. Without scaring them, I wanted to convey just how serious things had gotten, how dangerous New Orleans was becoming. I felt that they needed to evacuate and soon, that it was only a matter of time before they would become victims. This was no place for them to be; medical services were gone, the heat was oppressive, and sitting and waiting was all there was to do. The house meeting convened, and I found out later from one of the sisters that I may have been the first man ever to address their gathering. After some discussion, they made their decision. They were going to evacuate to Brenham, Texas, to another Poor Clare monastery. Their exodus began.

Hours later, when the cars were packed and I was given my instructions on how to operate the house, we said our good-byes. Tears welled in my eyes, pain swelled in my heart because one of the sisters had told me she was worried they might not ever get to come home to the only home many of

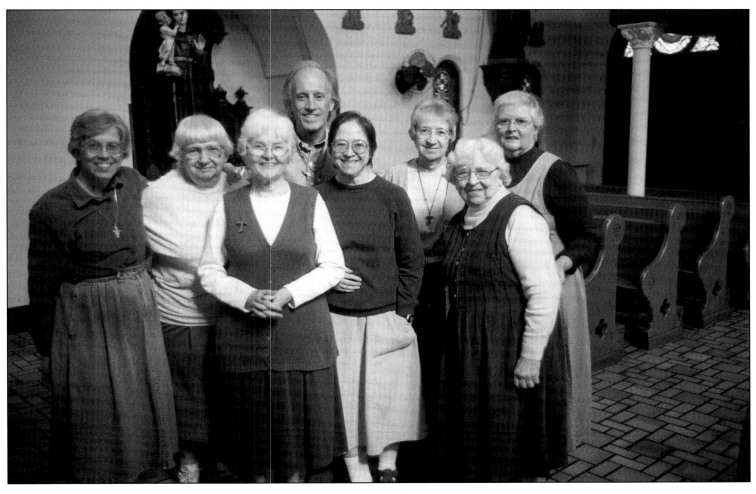

The sisters and I reunite after their biblical forty days away. *Photo by Tom Neff.*

them had ever known. I also found out later that this was the first time in the history of the order here in New Orleans that they had evacuated. So with the house keys in my hand, I watched them leave.

My gray kitten, Walker, and I were now really alone. I had promised I would do my best to protect the monastery from looters and whatever else might happen. But what was I going to do? I still didn't have a clue as to the scale and depth of destruction facing my city. I wasn't in touch with the outside world. I couldn't move around the city because the roads and streets were still blocked with downed trees and power lines.

I did know that I wanted my running streak of over twelve years to stay intact. I wasn't going to let Katrina take that away from me. Each day, early, I would go out and run in Audubon Park. While running, I would think and plan my day. On one visit to my gallery, I realized that my landline was operational. The seed was planted. How could

I use that and communicate with the outside world? Then I thought maybe if I could get another generator, my DSL might work, and then I could transmit images to my agencies in New York and Paris. Now a plan was forming. Where was I going to come up with another generator? I needed more supplies. How was I going to make my stand without gasoline? And cat food for Walker?

The city was practically empty, and the little news I was getting was that the mayor wanted everyone who had stayed to get out and now. The National Guard was pouring in; they were trying to rescue those who were stranded because of the flooding. Attempting to make my way around in my car, I stopped on Tchoupitoulas Street to photograph the looting of a Wal-Mart and almost became a victim again. Something caught my eye; two men were running toward me. I had left the car motor running and my door open. A car jacking was about to take place. I took a couple of quick steps and was gone. Just down Tchoupitoulas around the bend, just out of sight of the store, there were two NOPD cars sitting in the middle of the street, the officers talking. Not an ounce of concern about what was taking place just up the block. Lawlessness was a huge and scary problem and it had to stop. Order needed to be restored. What was I going to do?

On another run and after sharing my thoughts with Walker, I came to the decision that I should make a break, slip out, and try to gather my needed supplies. At this time there was only one way out, Tchoupitoulas and over the bridge. As Walker and I hopped in the car and started the journey, we saw hundreds of evacuees walking over the Mississippi River bridge. Their presence was making it clearer that this was a huge event and I needed to document it. So much was going on, and I still didn't have a handle on what was happening.

Heading north toward Jackson, Mississippi, and Monroe, Louisiana, I saw the roads littered with abandoned cars, people hanging around gas stations. It appeared that everyone had lost power. I did hear on the radio that winds were almost 100 miles per hour, tree damage was extensive. Nothing was available in Jackson, so I drove on to Monroe. Shelley and Sasha were staying with family and friends there. Arriving late, I sat down and started to watch TV and see what I had been missing, being in the belly of the beast. I couldn't believe my eyes. New Orleans was almost all underwater. The area where I live and work hadn't flooded. Katrinaville, as I started calling it, was safe, but the rest of the city was drowning.

What was I going to do; the world's news organizations were streaming into New Orleans. How was I going to compete with them? Plus every generator and all the other needed supplies were gone. The shelves of the stores in Monroe were empty. Moving on to Mobile with Sasha and Shelley, I located a small generator. After buying supplies and receiving the film and equipment I had arranged to ship to me there, I made my plan to return.

I had almost fifty gallons of gas, cat food, boots, rubber gloves and masks, jars of peanut butter, and bread. I was almost ready. But how was I going to get back in? There was a total lockdown, no one allowed in according to the TV. Being a fully credentialed member of the press wasn't a guarantee of admission, so after lots of thought and several runs I decided to make my entry in the middle of the night. Leaving Mobile just after midnight, I headed home. Back to what, I wasn't sure. The roads were dark, very little traffic except for the military heading in.

Another decision faced me. There was only one way in. The east side of Interstate 10 was closed as part of it had been washed away, so I would have to drive past New Orleans and come in from the west by Hammond. Well, that was a lot more driving, and wasted gas. I had heard that the Causeway was open but only to military and emergency vehicles. All

they could do was refuse me, so to the Causeway I headed. Sandbag bunkers and men in full combat gear came into view. What was I thinking? Then I noticed they were from the Oklahoma National Guard. Being a native Okie, I started talking, fast talking, hoping not to be turned back. Soldiers walked around my car, shining flashlights and looking into my stuff. I guess they figured a middle-aged man with a cat and not much hair didn't pose too much of a threat. Permission was granted, and across the Causeway I headed. The only lights on the bridge that night were my headlights. Although it was a trip I've made hundreds of times, it was surreal. In front of me was nothingness. No lights, no office towers in Metairie, no Huey P. Long Bridge, no Mississippi River bridge, nothing. It was as if New Orleans were gone.

During my brief time out of the city, I saw how the news media were spinning the story, and I felt that they were missing so much. I wanted to capture the deeper side, not just the cliché images that rocket around the world. So I decided to try to send out an e-mail a day with an update of what I was seeing and feeling. Picking about 200 friends and clients from my address book, I began, never thinking that these notes would mean much or be kept by so many. Months later it was becoming clear that my e-mails were taking on a life of their own. Being forwarded and forwarded again, they were eliciting responses from all over the world. One day I got a call from a fellow in Tokyo who told me that he had been getting my messages and wanted to know if he could send me some money. "What?" I asked. Then, embarrassed, I said no. What was happening? Then two French documentary crews found me because of my e-mails, I was interviewed by several independent crews, and for months I was stopped by people wondering if the sisters had returned.

I

Katrina . . . You Bitch

On Thursday, the day after the sisters left, I plugged my PowerBook into a landline jack in the monastery, and getting a dial tone, I signed on. I sent out a bulk e-mail to about 200 friends and clients, but many bounced back undeliverable. I tried to send another e-mail on Saturday, but my AOL account had been blocked. Not knowing why and unable to contact AOL, I was now without any means of communication. So my decision was made. I needed to make a break, get my AOL back up and running and get a generator, as I hoped my landline at The Rink might be able to transmit images and messages. I also needed gas and many more supplies since it was becoming apparent that this wasn't going to be over quickly. I left New Orleans on Saturday and found out that AOL froze my account because they thought someone had stolen my password and was using my e-mail for something illegal. From then on I sent every e-mail out in ten blasts, to about twenty people per blast. I sent my Saturday e-mail from the road, at a pit stop with Internet service.

Back in New Orleans, I relied on the tried-and-true method of hitting the streets and finding out all that I could. Much of what I was hearing was just too unbelievable or so I thought, figuring in the early days the stories, like our emotions, were blown out of proportion. Then as each was confirmed by others and I was able to fly with the California Highway Patrol, I began to see firsthand what had happened to my city. Once driving was possible, meaning the roads were being cleared, my world got bigger.

Getting in and out of the monastery was a challenge, as I had to park my car at the gated auto entrance and run around to the front gate, unlock, relock, and move quickly to the front door, getting in, running through the house to the back door, and then unlocking the steel gate, pushing and pulling it open. Moving my car into and closing everything behind me. This took place at least twice a day and sometimes more often. All my gear was in the car, and I was worried that during those minutes I was making my way into and through the monastery someone might break into my car.

This event of Hurricane Katrina was going to affect a region, just as the Dust Bowl affected my native region years ago. I wanted in my small way to try and capture photographically what was happening.

Through a window in the convent, the first light of August 29
reveals fallen limbs and trees.

SUBJ: Thurs. 1.IX.05 Day 3 after Katrina

To All:

I stayed for Katrina. The city is a mess, Uptown is altered forever. You couldn't travel more than a block without being stopped by a tree in your way. Most of the damage around Audubon Park and the Garden District was tree and roof. Water wasn't a problem, looters may be, time will tell. I stayed with the Poor Clare Nuns to make sure they were safe, and they left yesterday after we lost water pressure. Watching the looting, watching the lawlessness was awful. While I was trying to take a picture, a band of young men tried to carjack me, I saw them running and I took off. As I was driving out, seeing hundreds walking across the bridge was something out of a movie.

Audubon Park is a total wreck! Not much good news to share, but I did get my run each day!

Thanks for your notes, my eyes fill with tears, wondering when we will see each other again!

David

David G. Spielman
Photographer
New Orleans
318-235-3696 Hurricane Katrina cell
508-899-7670

SUBJ: Sat. 3.IX.05 Day 5

To All:

My world is Uptown, guess I should call it Katrinaville? The streets are being cleared little by little. Nat. Guard everywhere, pouring into the city faster than the water, the only traffic on the street are the Humvees and military trucks.

Checkpoints everywhere, guard camps being set up in Audubon Park, Children's Hospital, schools and firehouses. Helicopters, overhead day and night like dragonflies hovering over a pond.

My runs in the park are strange as it is only the birds, squirrels and waterfowl there with me. The camped Guard are amused by me running, must be betting this old guy is nuts to be out doing this, after all this. Life in the Monastery is strange, so quiet, yet the presence of the Sisters is there. Each morning I go into their chapel and say a prayer for them and us. I keep a candle burning for them in front of the altar. I then ring the bell in the hall outside the chapel three times, reminding God that they might not be here but please don't forget them.

Still no sign of the police, their absence is very noticeable, NOPD seems to mean No Police Dept. I get checked often at roadblocks, but my station wagon, gray and diminishing hair, I think, helps in reassuring the soldiers I'm not a looter. If it weren't for the Guard this place would be taken apart by the looters.

More later,
David

SUBJ: Sun. 11.IX.05 Day 13

To All:

Back in the "belly"! Made my entrance very early this morning, left Mobile at 2 A.M., slid up to my house about 5 A.M., don't want to share the details as I used a back door or two to get into town. The National Guard plus the Jeff Police wanted to keep me out but to no avail. Not sure if it was my fast talking or the starched shirt that convinced them I wasn't a crook!

Happy to report the huge National Guard group is

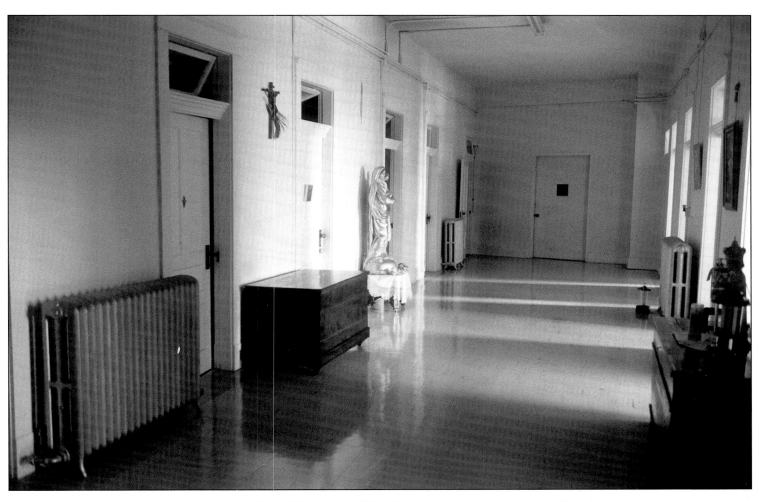

A hallway in St. Clare's Monastery fills with early morning sunshine. Candles and battery-operated lanterns provided light at night.

stationed next to Children's Hospital and another around Audubon Park. Camp Audubon is what they are calling it. The streets are pretty much open, when I left on Wednesday after the storm you couldn't go a block without being stopped by a downed tree. The military is patrolling the streets. Twice a group passed by The Rink, knocking and making sure the doors were locked. The Rink is in great shape, no break-ins and I spent some time watering the plants. Barry has got to talk with the plant service, they're not living up to the contract.

Strange approaching the city and not seeing any lights, so very quiet, the only noises are the helicopters overhead and the army trucks on patrol. I'm up and running, will be sending images and more information.

Remember if I can help, write or call.

Better sign off and get to work!

All the best, more later,
David

SUBJ: Mon. 12.IX.05 Day 14

To All:

You wouldn't believe the change in the city, streets are tree free, the National Guard is everywhere, lots of checkpoints, trying to keep the looters out and let the big work get done. I haven't seen Entergy just yet, but I'm betting that once the trees are cut back, Entergy will have a clear field to run with and they will make short order of the job.

Canal Street has become media central, TV crews bumping into each other, the hotels are full steam ahead fixing windows and removing damaged goods. Military everywhere. Cops from across the country. The smell of rotting food is everywhere, I spent the morning cleaning out the freezer of decaying meat and chicken, wasn't hungry all day.

You can smell the rotting food as you move around, much like that smell of a burnt house.

The water is moving out very fast so be patient and let the pros go for a while longer. The real story is how fast things will return to normal. Our city is forever changed. Lots of landmarks gone, the trees, neighborhoods look like toothless kids, the park, St. Charles heartbreaking.

Last night I awoke, gunshots, didn't know how many. So this morning after my run I stop and check in with the National Guard and I asked, Magazine and Exposition Blvd. So it isn't safe just yet. They said NOPD responded and they weren't called.

More later,
David

SUBJ: Tues. 13.IX.05 Day 15

To All:

All your calls and notes are wonderful, but it is apparent that I need to clear up how and where I am. My house is fine, some roof damage and one broken window, lots of loose boards but still standing and very livable. The Rink, where my gallery is, is also fine, some wind-blown rain got in but other than that I think fine. Shelley and Sasha are fine over in Mobile with one of her sisters. Her house is fine, several of her family have suffered huge damage to their homes.

Now Walker, my cat, and I are staying at the Poor Clares convent, the National Guard thought it a better place than my house, with a generator running and lights on in my house I might become a victim. Agreeing with them, the Sisters offered their place to me. Walker and I are very comfortable. The Sisters are and will be for a while over in Texas at another Poor Clares convent. I talk to them most days giving them updates and telling them that I am trying to take very

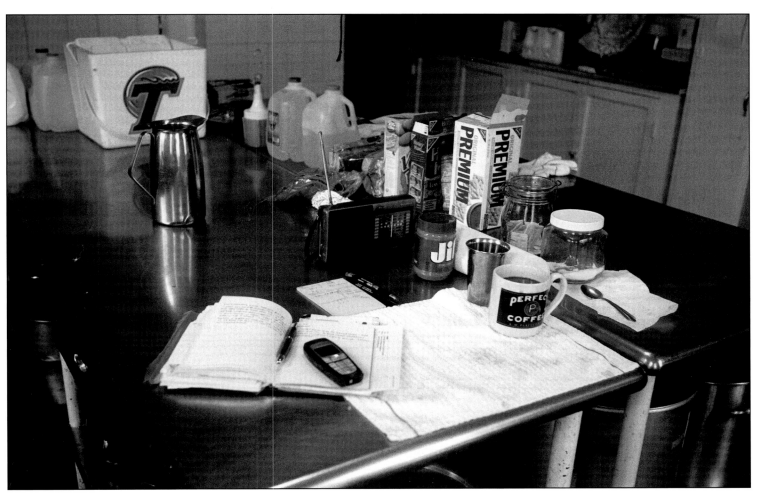

In the convent kitchen, bread, peanut butter and bottled water are my MREs
("meals ready to eat" in military speak). Living without electricity and
running water challenges the senses.

good care of their home. There is something odd about me living in a convent, haven't put my finger on it just yet.

Sleeping isn't easy, laying on top of the sheets, just breathing, sweat sliding down your face. No air moving, dark, so very dark. The only noises are the military trucks moving back and forth. Waiting for the morning light but then being so very tired from a sleepless night.

Better get out there and find some photos.

Thanks for all your notes and calls, hoping to see all soon!

More later,
David

SUBJ: Wed. 14.IX.05 Day 16

To All:

Another adventurous day in N.O. Since my life runs on gas and I'm running low, a good part of my day is trying to figure out how and where to get fuel. My car and generators use it and my world revolves around it. Nothing positive as of yet but I've got some more leads to follow tomorrow. Eating mostly peanut butter sandwiches and lots of water, craving a big salad for sure.

Every corner you turn you find something to shoot, the trees, damaged houses, mud, water, items moved like ping pong balls in a pool of water. The work continues, to clean up the place. Some are getting excited that it will only be days before it's back to normal. I'm not convinced of that, remember we, Uptown and French Quarter, are the center of a wheel and everything around us is in worse, much worse shape than us. So we might be on the mend but everything that brings us our services isn't up and running yet. Time, and more time is what is needed.

During my morning run, there next to a military truck

was a young rabbit, eating grass just as if nothing was wrong. Hundreds of soldiers sleeping a few feet away. The ponds are full of birds looking for the bread they have grown used to. Strange traveling the streets, no stoplight and every mile or so a checkpoint making sure you are there on business, not monkey business.

The weather remains hot, no rain, the flies and mosquitoes are getting really bad. The piles of garbage, well you know the smell. Enough said.

More later, the hunt for gas continues
David

SUBJ: Thurs. 15.IX.05 Day 17

To All:

Let me start by saying I'm not wearing a starched shirt each day, many have asked! Knit shirts, not very happy about that either. I'm also wearing short pants due to the heat. I haven't worn short pants this much since I went to summer camp at Kanakuk Kamp a million years ago in MO.

Lots to report, Entergy trucks abound, our Mayor says maybe Monday some can start coming back. Wouldn't that be nice, can't wait for a Starbucks. This heat and smell is very trying, you don't escape it ever. The rotting and mildew smells are everywhere. There is no one to talk to. Weird things happen, I was driving down a street and I was lost because of all the trash and trees, realized I had driven past Cafe Degas, turned back only to find it smashed. The big tree which was the center of the restaurant is down, along with most of the roof. One of my favorite places is in total ruin. My heart sank, realizing that there must be dozens of icons like Cafe Degas.

Later I had an assignment to shoot the first Fed X plane coming back into N.O. So through many checkpoints I get

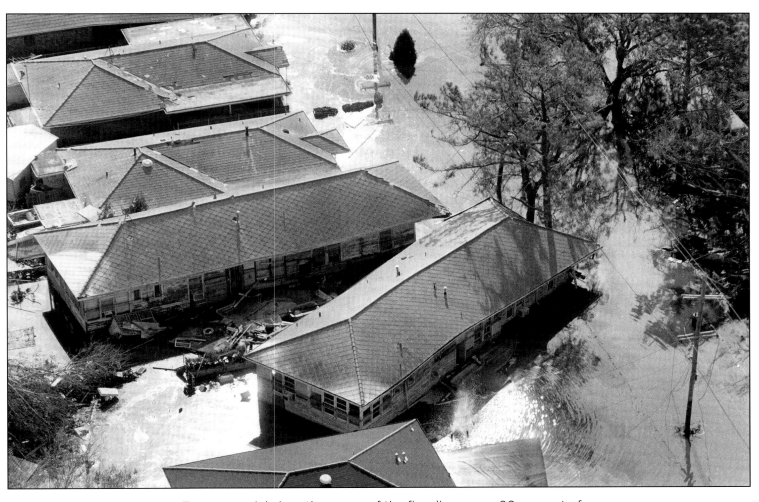

From an aerial view, the scope of the flooding—over 80 percent of the city—becomes apparent to me for the first time. Block after block, neighborhood after neighborhood, tells a sad story.

to the airport, Kenner is lit up almost normal. Shooting the assignment finding out that the cargo isn't really for N.O. but will be trucked to B.R. and Laf. I also found out that nothing can be shipped in for maybe three weeks. If someone wanted to ship something to zip code 70115, the Fed X computer won't allow it.

Oh, remember my rabbit I saw the other day by the army trucks, well he or she is now so brave as to be hopping around the tent area of the soldiers. I thought for a moment that maybe it was a stuffed rabbit, looking at some of the little boys in uniform, well it could happen, but then it started hopping.

Can't wait to see all of you again,

More later,
David

SUBJ: Fri. 16.IX.05 Day 18

To All:

This day rates way up there, had no idea how it was going to play out but it was a keeper. Long shot, might get to go flying, well, it happened, the other LA, as in Calif took me up for a ride of my life. We flew over everything and I thought I had a handle on the mess, not even close, my life won't be long enough to see it all put back together. Shrimp boats hundreds of yards inland, yachts stacked or piled on top of each other like bits of driftwood, houses moved off their foundations, houses torn apart. The water is going down fast, faster still. Pack of hungry dogs chasing deer in N.O. East. Places I once knew that are gone, not busted up but gone. These Calif pilots were amazing putting me on the dime, images that should be from a war zone, big bomb-types of images, not our home town.

Oh, so while flying out in the East a different smell filled

the copter, the stink of decay and rotting food was always there but a new smell, so the first mate expressed some concern, next thing I know we are looking for a dry spot to put down. Well, you are getting this note so it all turned out just fine, after a complete inspection of the aircraft we continued on. Boy, that would have been a drag to crash in that mess!

Images for Fed X and the first shipment to be delivered to N.O., so I rode around with a driver trying to find the houses, more firsthand experience on just how big this thing was and is. Remember the last summer and early autumn smells GONE! Just wait until you get a nose full, good luck!

The GI's in the park were sleeping as I passed, I running earlier as I'm not having enough time in the day to get it all done.

More later,
David

SUBJ: Sat. 17.IX.05 Day 19

To All:

Last night brought a wonderful light and thunder show, with some rain, which was the first since the storm. The rolling thunder, starting low and slow, building, flashes of lightning dancing around the sky, amazing. Here at the monastery it was really nice in this old building, its brick wall, the thunder filling all the spaces and the echoes made you feel it all over. The rain wasn't very hard but its sweet smell knocked down the stink of the rotting whatever and the air smelled sweet for a while.

Yesterday was a day of transmitting images to the different sources that will be publishing them. Checked in with Brobson L., a friend and Dr., he seems to have a direct line and has lots of late-breaking news. It's amazing how we all seem to find each other, cell service is spotty at best and

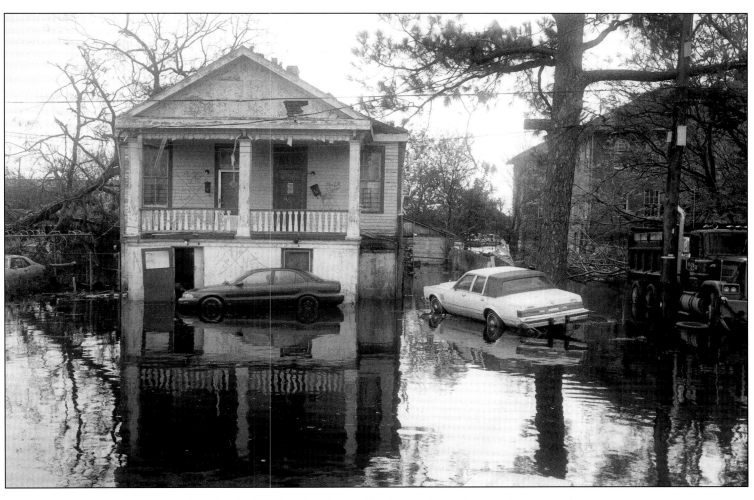

Just below the Industrial Canal near the Mississippi River, as the water begins
to recede, the devastation becomes apparent.

all those who are here help each other. Some help with the much-needed gas to run generators, others help with food, I'm bringing the media to Brobson for interviews. There is a very different post-hurricane pace, things take so much time, moving around is difficult, checkpoints, questions, you have to hear their stories, so many questions are asked of me because of all I have seen. You also need to be off the street by dark, then it is really weird, no light, so quiet, still some bad guys moving around, always looking around as I'm taking pictures wondering if someone is going to try and carjack me again.

Thanks to all for your wonderful notes, I can't answer most as I'm working off a generator and the gas supply is limited, fuel and water one doesn't waste. Know you are all in my thoughts.

I hear cars on the streets, they are letting some back in. If only they could have seen it right after the storm.

More later,
David

SUBJ: Sun. 18.IX.05 Day 20

To All:

Autumn is nowhere in sight, the weather remains hot and feels much hotter without our A/C, boy do I miss the A/C.

Saw some new faces as people are being allowed back in, I hope the heat and smell don't run them off. The Uptown area looks so much better than ten days ago. Now the slow, very slow process of building back begins.

I was in the St. Roch Cemetery today shooting. The water must have gotten about five feet high. The cars that remained are completely covered with mud and oil-type gunk. A thin layer of dirt covers everything, yards are brown as the water smothered the grass and plants. Felt like I was in a Sci Fi

movie, houses there, cars albeit they were covered with mud, so very quiet, lots of crows in the trees. Very strange! As the water level dropped, there are these lines on the cars, houses and walls telling you how much the water dropped each day. The only thing moving were some big dogs that were left during the storm, scared and very hungry. I found some animal rescue teams and told them where I had seen them. They told me that they were running out of cages. So many animals, they even saved someone's parrot today.

While in the Quarter later in the day the streets are being patrolled by Nat Guard units. Some good news, there haven't been any murders of late.

More later,
David

SUBJ: Mon. 19.IX.05 Day 21

To All:

This morning I was greeted by the full moon, my running friends know I count the hot months by full moons, so after the next full moon our temps should get cooler. Summer is coming to an end. Back to the moon, being in a dark city, with just the moon guiding me around the park, very nice. Moonbeams dancing off the water of the lagoon and darting among the trees. My solo time in the park is coming to an end. For the thirty-plus years of running in Audubon I have considered it my park after this storm and being the only one in there for many, many days it really has been my park. What a special and beautiful place.

Pretty quiet Sunday, well sort of, lots of new arrivals, looking at the damage and trying to deal with their losses. Guess it was an NFL Sunday somewhere but no news about sports here, everything is about the storm and its aftermath. One rumor flying around is that our Mayor was visiting his

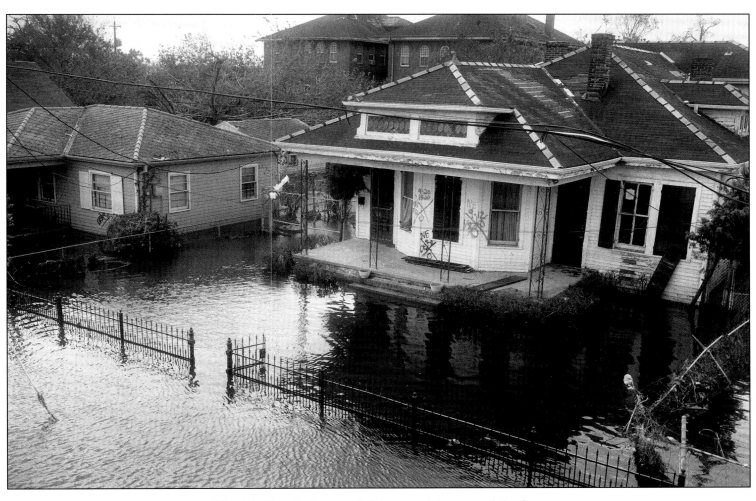

The St. Claude Avenue Bridge provides one of the few
vantage points for weeks.

family over in Dallas, where he is supposed to have bought a new house. I wouldn't want to make a comment on such developments, because I voted for him and feel quite sure he wouldn't make such a silly mistake. Oh well time will tell!

Here at the Convent, Sunday was just the same as all the rest, no Mass, no sisters singing. I've got to wonder, this must be the longest period of time this monastery has been without the Sisters? I did see Judge Dennis W., he had passed by wondering, worrying about the Sisters, when I told him where they were and they were all safe he was relieved.

Saw a power company from Canada, whose crew was from upstate N.Y., it is amazing how far-flung the recovery effort is. The other day a group was from Germany, with Mercedes Benz trucks, would love to get their impressions of the Big Easy right now! The most common sound seems to be chain saws and heavy lifting equipment removing trees and trash. The wonderful streetcar rattle isn't there just yet, can't wait for its bell to be ringing on the avenue again.

I'm sure all of you are aware that Tropical Storm 18 is out there, please keep an eye out for it. Oh, before I go, got a call today from a friend, asking how I was, there was a pause in the conversation, he ordered a cherry limeade, I almost died. I haven't had an iced drink since I don't know when. The little things are the most missed!!!!!! Like seeing all of you!

Be Safe
More later,
David

SUBJ: Tues. 20.IX.05 Day 22

To All:

Please excuse my Okie-isms, not even sure how to spell it, I've noticed some of my notes contain some rushed sen-tences, missing words. Even with my limited brain power my thoughts come faster than my fingers can type. Also remember you are seeing one of the many reasons I'm a photographer instead of a writer.

Well, I guess we set a record for a high temp yesterday, it's supposed to be hotter today. How did they do it without A/C, sweat is continually pouring from my body, I've noticed that people don't linger around me much anymore? We may have all or get part of another storm, I can't imagine going through this again, so soon. Time will tell. If it comes I may serve food to the Red Cross.

During my run this morning I noticed the National Guard unit stationed at the Magazine St. entrance wasn't at their post. Then when I got around to Children's Hospital, the Texas unit had pulled up stakes, gone, as if they were never there. Interesting? Wonder why, are they pulling out before the storm or maybe moved to another location in the city. I need to find out what happened to my private security force.

The work downtown is moving along at a fast pace, hotels and office buildings are throwing everything at the prob-lem, to get back up and running. Helicopters are putting new units on tops of buildings, cleaning crews are work-ing around the clock. The thousands of broken windows are being replaced, and still no murders, life is good in the "hood." I was also in the Quarter and was looking for some Red Beans and Rice but no luck!

Saw a few friends and am getting calls from others who are trying to get in, clean up and get out. One friend who was so eager to move back in, called after being here for a day and a half, said he was headed out and wasn't coming back until power was back up and running. He had never experienced anything this tough.

This is REALITY TV, no limos, no one-hour shows each

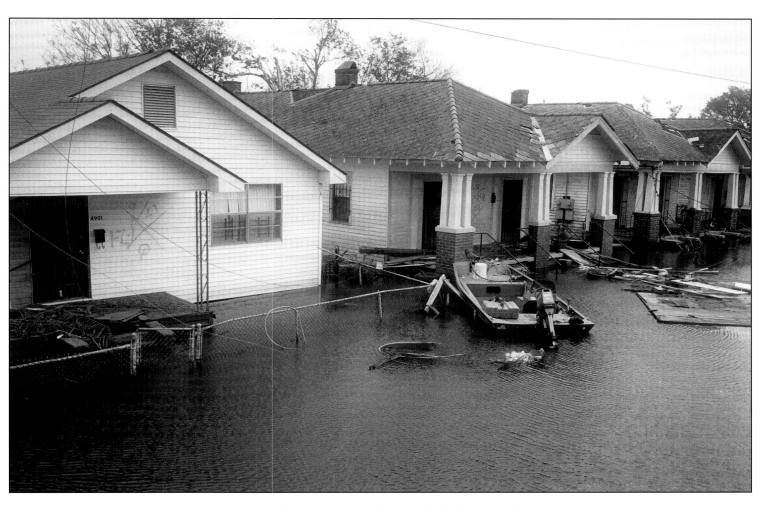

A scene found throughout the Lower Ninth Ward and beyond.

week. This is Lower Ninth Ward New Orleans, Lakeview, Uptown, 24/7, no commercial breaks, hot and sweaty, smelly and no make-up. Living "ain't easy" down yonder in New Orleans.

More later,
David

SUBJ: Wed. 21.IX.05 Day 23

To All:

Laundry last night, oh yes, the joy of roughing it. I think my whites are going yellow and my darks are getting muddy. It's hard to tell as I'm doing it by candlelight.

The Guard has left the Park. I understand where the TX Nat Guard went but this morning everyone else is gone. Very quiet this morning no military generators, no trucks idling, soldiers waking. Just me, the moonlight, nighthawks and a few owls. I must say you really can't tell they were ever there. Hundreds of soldiers, equipment, tents, helicopters and all the support stuff gone, as if it was never there. The really good news is that they left it cleaner than they found it, something most of our citizens should learn.

Heard hammers yesterday, lots of chain saws, still no power, they have got be getting close. I'm sure I must have four or five different types of heat rash. Does anyone know if your sweat glands can just quit or break? Mine have been working overtime and I'm afraid might give out before Entergy gets my power back.

Got to shoot pictures of a Garden District home that had lots of water damage from a blown-off roof. My heart ached seeing this old beautiful home broken and scarred. Realizing of course that we really don't ever own the beautiful places, we get to be the caretaker and then they are passed on to someone else. This old house has probably withstood many storms, and will continue to do so long after we are gone.

I can't even begin to tell you the stories I've heard, I would never get any shooting done. Believe me they are amazing both in good and bad ways. I did hear today that all the cars that were parked in a French Quarter parking garage were all stolen during the storm. The few that remained were wrecked by breaking the windows, removing the gas and stealing the wheels. I'm not talking about two or three cars either. Lots of cars were stolen.

Maybe just maybe this new storm will keep going West, we sure don't need another replay of the horror movie called Katrina!

More later,
David

SUBJ: Thurs. 22.IX.05 Day 24

To All:

Yesterday was one for the record books! Needed gas for my car so I tried to sneak out to Jefferson and fill it up. OK, so that went fine, well while I was out of Orleans, Nagin called for a mandatory evacuation. So I get back to the parish line and NOPD says you can't come in, of course they don't get it that I've been in, nor do they care, they aren't letting anyone in. Like talking to a post, come to think of it I've talked to posts with more concern and understanding. Well, not to be outdone by our police dept. I took off and zigzagged around and found a National Guard post, explained what was going on and in I went. Wasted about an hour with that little distraction. Nothing is easy, getting gas is an adventure.

So now I'm going down to Arabi, to see and shoot what I can. Driving in I am stunned, really stunned. Remember the WWII newsreels of the bombing raids on London? That's

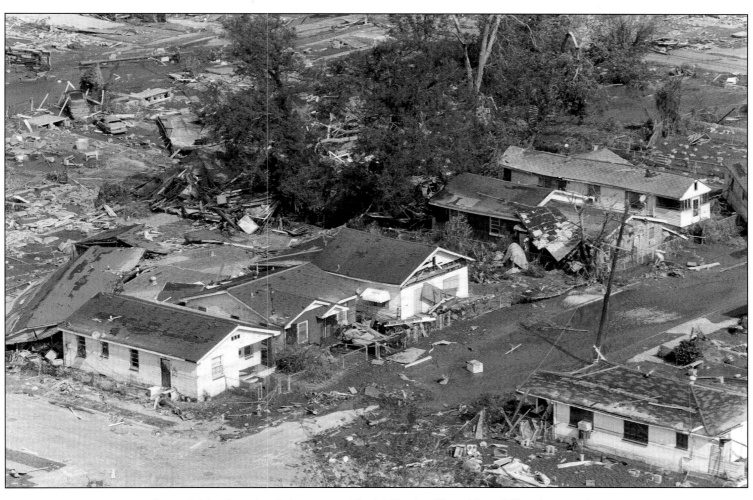

The neighborhoods of the Lower Ninth Ward suffered bomblike destruction,
houses ripped apart by water rushing from the levee breaks.

what this reminded me of. Everything was dead, the water must have been about five or six feet by the watermarks on the buildings. Cars were turned upside down, looked like dead roaches, boats in trees, houses knocked off their foundations. Miles and miles of this, every corner I turned more of the same. All brown like the newsreels, nothing moving except maybe a crow and a lone pit bull with a broken rope around its neck. Front doors broken open, looking for survivors, the marking on the outside letting you know when and if bodies were found. Weird sights, children's toys hanging from wires leading to the power poles, houses that floated into the middle of a street, other houses that crashed into each other, some rotated 45 degrees on their property. Words and pictures can't convey the surreal nature of this place. No noise, dead quiet, all the cars covered with mud, the mud on the street and sidewalks cracking, taking on a fudgelike look. Then when the wind would blow, a piece of siding or a tin roof would tap or scrape, scaring me. I fully expected to see some half-crazed person stumble out of one of these houses. This was a Sci Fi movie, but yet I'm sweating and smelling the stink of decaying food and whatever else was there decomposing, I'm there, not sitting in front of a movie screen.

Rebuild, where would you begin, how would you begin, lots of these little houses are hard-working folks who I'm sure are underinsured, older folks, the place is a wreck. Remember I've only seen one or two neighborhoods, this goes on for miles and miles and miles. I know I've said this before but this thing is so huge I still can't get my mind around it!

I went back into the St. Roch Cemetery, spent a little time walking around, worried sick that I was going to be the first murder in N.O. The watermarks on the walls, the flowers and vases cast about, the chapel with its upturned pews, even the dead have to be sick and saddened by this storm.

I know I can't possibly convey through my images this destruction, as I can only cover a limited field of view. My pictures are flat, no smell or sound comes from them, you look into them. There in Arabi you are surrounded by it, it is so much bigger than you. It just upsets me so, to think of all the lives that are wrecked, the architecture that is lost. Their world destroyed.

Well, I'm closing some of the opened shutters at the monastery, looks like we will get a bit of Rita. Isn't it just like Texas to outdo us, they always have to have the biggest and best of everything.

More later,
David

SUBJ: Fri. 23.IX.05 Day 25

To All:

Wow, here we go again! Without listening to the news you could tell something was up. Police and National Guard rushing about, high energy in the air, no one was just standing about and talking. The TV crews were clearing off Canal Street. All day long the reports kept confirming that LA wasn't going to be passed by. Driving back to the convent N.O. was even more of a ghost town than before. Fewer National Guard, very few city dwellers. The feeder bands were making their presence known, pelting rains would come and go. Hard to believe this is all happening again. Hoping all the good work by Entergy isn't undone. Hope the levees hold. You can feel the change in the weather.

I drove through Old Metairie, oh my, those wonderful big houses all had about four feet of water. Ten-foot-high piles of stuff out in front of most of them. Carpets, furniture, sheetrock, computers, TVs, kitchen appliances, you name it, it was all there. Millions of dollars of ruined stuff. Where will it all go? For the next twelve to eighteen months where will all these people live? Where will their kids go to school? Shop,

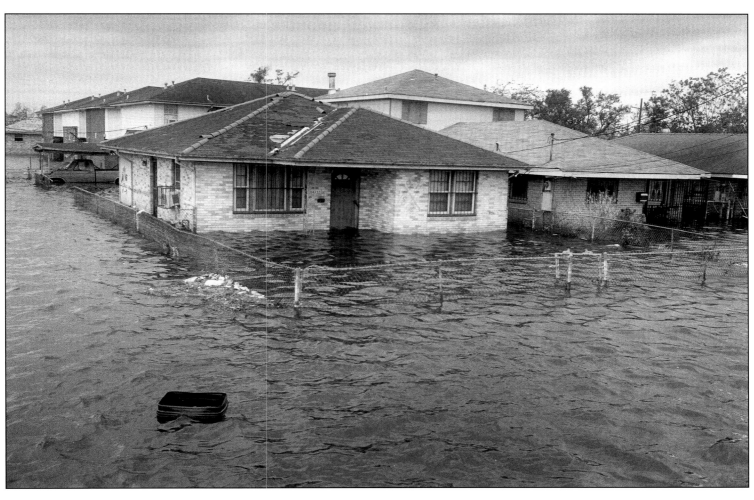

As the water drained, the Lower Ninth Ward filled again
with rain from Hurricane Rita.

play, eat and all the rest of the things we take for granted!

My photo editors in NYC and Paris can't get a handle on just how big and widespread this storm was. When I send such diverse pictures as Arabi and Old Metairie, stray dogs, overturned cars, they think I'm shooting two different stories. When I explain how close it is all together and how we are surrounded by water, I can just see them sitting there trying to figure out why we choose to live here.

Walgreens on Tchoupitoulas is open, they have to be the first Uptown and are probably the only place open that I know of. So I went by to see what I could see. The majority of the cars in the parking lot were military vehicles, so I go inside, soldiers all over the place buying magazines, candy and lots and lots of food. So I ask one soldier are you getting enough to eat, he said he was bored with the MRE's, needed a break, something different, microwave popcorn to munch on during the movie. I stand there and think of the one hundred peanut butter sandwiches I've eaten, no movies, no TV, just relief radio. I considered for a brief moment, about enlisting just for the food! Bet they're watching Band of Brothers!

So here we go again, you will hear from me on the other side of Rita!

More later,
David

SUBJ: Sat. 24.IX.05 Day 26

To All:

The second day of autumn, are we having fun yet? Egrets, herons, ibis, squirrels and owls were all present this morning for my run. That tells me we didn't have it too bad. A few new limbs down, nothing major. Some of the piles of stuff on the streets were rearranged. It was a long night, up most of it checking the convent, boy that place has lots of doors and windows. Happy to report all is well. Some rain but really not that much. Checked around the hood and all seems to be in order. Did notice an increase in military patrols, which is good. NOPD has been absent from wherever I've been.

I'm headed out to see the other parts of the city and see if there are any stories that need to be told. I'll write more later, as I got a late start this morning because of the all-night watch I was on. I do hope Rita came in on the LA side of the state line, I think that would mean more Fed dollars for us.

Walker, my cat, followed me around the house on every round, there at my heels just like a dog. She seems to like this adventure as much as I do. When I'm bathing she walks around the edge of the tub.

More later,
David

SUBJ: Sun. 25.IX.05 Day 27

To All:

Once upon a time not so many weeks ago, my Sunday would play out something like this. Sleep in until 5 A.M., rise and run, have some coffee, shower and shave and make 8 A.M. Mass with the Sisters. After Mass off to get two large coffees with steamed milk and a chocolate milk, with my NY Times in hand I would call on Shelley and Sasha. Now that is how Sunday is supposed to be! Well, let's see how my world has changed. Run at 5:30 don't want to get out before I can see the road, back for some coffee, no NY Times or TimesPic, note to self, check why my home delivery isn't! No Mass with the Sisters, I do sit in their chapel and say a prayer, light a candle and ring the bell. Hope that counts as church. The real day begins, I'm going to tag along with Dr. Brobson L. and photograph him checking on his friends and patients in and around the Quarter. Some are holdouts who never left, others are French Quarter characters who count

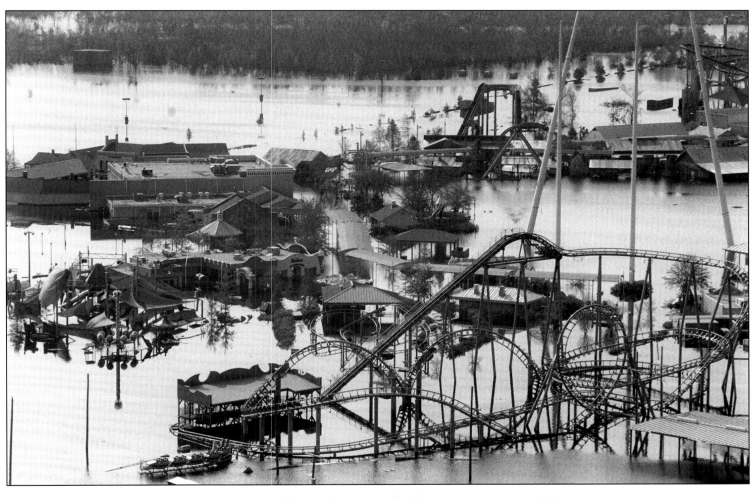

My helicopter ride took me over Six Flags amusement park in
New Orleans East. Floodwaters remained there for weeks.

on him. Hoping to tell his kind story in pictures, one of the many back-of-the-house things that go on while the rest of the world looks at the big picture.

Next, I've got to gather some gas for my generator, I've got to transmit images to NYC, check on several friends and sources and see if I can get any good information as to what is going to happen around here concerning the power coming on. All while staying under the radar, sometimes I pretend it is sort of like the French underground.

Yesterday, I went back to the Ninth Ward, the place had filled up with water again. Just like a bad movie, remember Bill Murray in Groundhog Day, when he woke up each day and had the same assignment! The water was almost at the high watermark. Off in the distance two dogs barking, stranded for over three weeks, crying for help. I was there just a couple of days before, remember, dry as a bone, caked mud, not anymore. It is so very hard to believe this is all happening. I really want to know who got us all in all this trouble!

I ran up on the levee in the park, the river is high, not the highest I've seen, but the most interesting sight is with the wind coming out of the south the river is flowing upstream. I'm guessing the wind is still blowing well over 20 mph.

So, see how my Sundays have changed in just a few weeks? I miss my old Sundays.

More later,
David

SUBJ: Mon. 26.IX.05 Day 28

To All:

Making the rounds with Dr. L. was an eye and earful. A Vietnam vet, a woman with a dozen dogs and one bird, whose partner died several days after Katrina. Now I'm suffering from flea bites, damn dogs! Checking with the EMS

unit seeing if any new patients or cases appeared overnight. Did see the young lady who made the national news, with her sign "Will show tits for ice," according to Brobson she and her boyfriend had more ice than they knew what to do with. Only in New Orleans.

Rumors were racing around the Quarter that power was about to be turned on, 11 A.M., then 2 P.M. We were walking on Royal a loud POW and all of a sudden alarms started ringing all over the Quarter. Then lights were seen and A/C compressors could be heard cranking up. People shouting, high fives, the quality of life just got a whole lot better. Strangers stopping and talking, excited about life returning to normal. Then ten minutes or so later everything went dark, alarms stopped, fans stopped turning. Everything was so very quiet. Minutes passed, word came down the street, a fire, a building over by Rampart was burning. The power was turned off. Sure enough, fire trucks racing through the Quarter. Not a big fire, something in the top of a small hotel but enough to put a stop to the return of the power. As of 8 or so there still wasn't any juice flowing in the Quarter. I have to wonder how are they going to handle restarting the power Uptown. I'm quite sure Entergy doesn't want to burn down anyone's house.

The wind is still strong and out of the south, I'm hearing rumors of a cool front making its way down yonder later in the week. That is the best news I've had in a while.

More later,
David

SUBJ: Tues. 27.IX.05 Day 29

To All:

I can't believe it, 29 days, boy time flies when you are having fun . . . NOT! One-twelfth of a year gone/spent

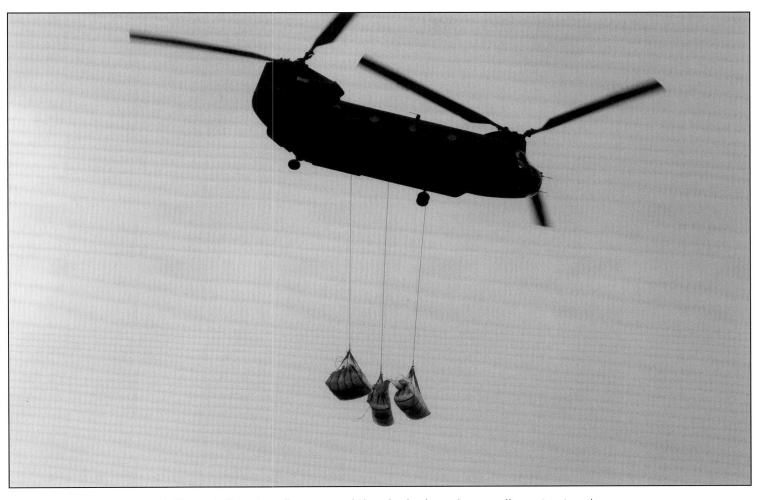

Military helicopters flew around the clock, dropping sandbags to stanch
the flow of water into the city.

digging out from a storm. Have you noticed the days are getting shorter?

Yesterday was a good day, lots of reasons, the Quarter got electricity. I scored some more gas for my generators, that's always a good day. Better yet I found some images that I hope will have some meaning someday.

I drove way down past St. Bernard, driving our LA backroads, finding nothing but more of the same. Then I came across a small cemetery. What a mess. Crypts overturned, others floated off their foundations, big trees toppled and broken over the graves. So I stopped, wanting to be respectful and feeling like this place hadn't been checked on. I entered. As I walked around, headstones all over the ground, flowers and their vases thrown about. As I moved to the back part of the cemetery there they were, caskets on the ground, upside down, standing almost upright. Even the dead were messed with by Katrina. Nothing had been moved, I was almost afraid to move. As I walked around ever so slowly there were more and more. This poor little country graveyard was in ruins, who is going to fix and repair it. Is it still in use, I sure don't know. Then over in the corner one casket sitting, almost resting, on top of a crypt. Looked as if it was placed there, but of course it wasn't. Very unreal! It was time to leave and as I was walking out I was so very happy that I had parked my car some distance away as not to draw attention as there were those driving along looking, stopping and taking snapshots of the destruction. I just hope they can replace and repair the graves before the angels and markers end up for sale somewhere.

This reminds me, I hope my pictures are respectful of others. I just know those families must be sick over the conditions their loved ones are in right now.

Little pockets of electricity are popping up ever so slowly, in very weird places, with no rhyme or reason. So maybe we are seeing the beginning of the end. Not that having power will change much as then the real work begins to rebuild the city. At least we can do it with A/C and ice in our drinks.

More later,
David

SUBJ: Wed. 28.IX.05 Day 30

To All:

Where to begin, at 12:24 the power came back on at the Monastery, I know this because the clocks stopped at 4:44 A.M. way back when, so I did some math and that IS the time the power came back on at Magazine and Henry Clay. My life got a whole lot better. Just as I was getting the hang of handwashing the bed sheets, as I had grown used to walking around the house with a flashlight in my hand, how each morning and evening was spent readying the generator, my life changes again. I never got used to sweating while I slept and I'm happy and glad to admit that. I am pleased to say I didn't miss TV. As a matter of fact this beats the heck out of any reality TV stuff Hollywood would like us to buy into. At a later date I will share with you the many things I've learned because of Katrina.

Of course I called the Sisters to tell them the good news. I'm on the speaker phone with them and when I share with them, they break into cheers and applause. Then lots of questions, their excitement was the best part of the event.

So now I go up to my room and turn on the A/C, Walker is scared by the noise, closing the windows was a cause for concern. Once she felt the cooler air, all that was forgotten and she stretched out on the floor and soaked it all in.

Then the house phone rang, not sure what to do I answered it. Someone was looking for the Sisters, I explained where they were and who I was, guess not many males answer their phones. Then she asked me to light a candle to St.

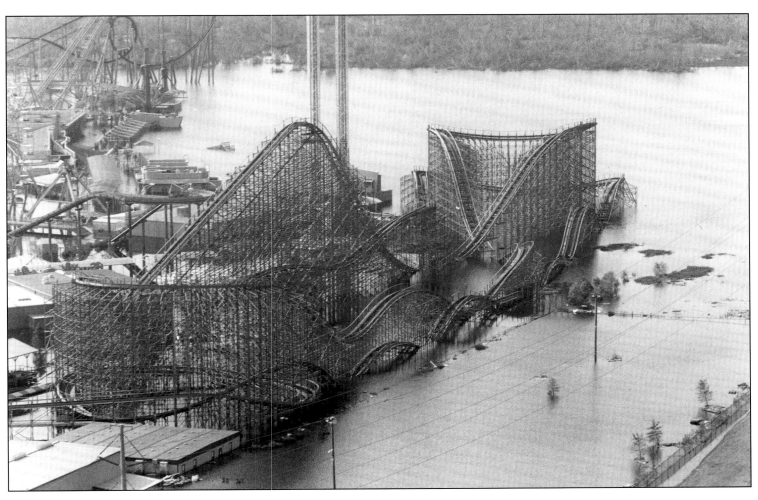

The roller coaster at Six Flags looks like a serpent rising out of the water.

Francis and pray that her daughter who found two Weimar-aners would find them a good home as she just couldn't take care of them. I explained that I wasn't a Nun and I shouldn't be praying for anyone other than myself. She didn't care, would I please light a candle and get the message to the Sisters, of course I said, I can do that!!!! As you can see, I better not answer any more phone calls while I'm here.

I've got to tell you the night before last was the hottest yet, not a breeze to be found, sleep wouldn't, couldn't find me, sweat everywhere, there looking at the ceiling wondering would this ever end. Now last night, clean sheets, the A/C cooling me and Walker, a fan moving the air about. I haven't slept that good for thirty days. I did when I woke this morning, grab my flashlight and light a candle, then realizing I wasn't sweating and I couldn't hear the insects from outside I reached over and turned on a lamp, blew out the candle and got ready to run!

More later,
David

SUBJ: Thurs. 29.IX.05 Day 31

To All:

Made a trip to the 17th Street Canal, oh that couple of hundred of feet and what it did to our city. Looking at it, shooting pictures of it, it is so very hard to believe how much damage it caused. I'm sure someone must have been at home when it gave way, as I've been without much outside communications I haven't seen any interviews as to what it must have been like. I wonder about the noise, how fast did the water rise. One side of the canal total destruction and the other as if not much happened. Two worlds in the same place.

Still getting used to the idea of energy, walking into The Rink, not having to start the generator, having it cool. A very pleasant condition I'm getting used to. More and more people on the streets, talking on their cells and running the stop signs, oh yea we're back! I guess N.O. is really going to be an adult city. Seems most of the school-age kids are somewhere else and will probably be gone all year. Now just us old farts hanging out. At least for this year no more long carpool lines at all the schools.

Well, after several minor cuts and scrapes I thought it a good idea to get a tetanus shot. With all the roof tiles, downed gutters and stuff, it is probably a good idea for lots of folks.

Well, it was bound to happen, I was given an MRE, meals ready to eat, right! It's a good thing I was never in the military, I might have starved. The instructions are lame, the trash that is created, the enemy could just follow the paper trail and find our army. My dinner was #15 beef enchiladas, think the #15 is like the numbers on those fancy wine lists? Waiter, I'll be having a #15 tonight! Well, I didn't leave it in the heater long enough, when it slid out of the bag it was hard to tell what it was. Mind you this is all after letting it warm up for fifteen minutes and trying to understand the instructions. And they are called MRE's. The good news was that there tucked away in the box was a tiny bottle of Tabasco, our State sauce. That made it all worthwhile. Give me my PB and whole wheat bread sandwich please.

Before I forget, you guys are the best, the notes and calls are so nice. As I'm stuck in traffic, or being turned away at a checkpoint, there you are. A quick hello, asking me if there is anything I need. Do I have enough film? I got an e-mail from a Lafayette friend yesterday, you just don't know how glad I am when I hear from you all. Thank you so very much!

More later,
David

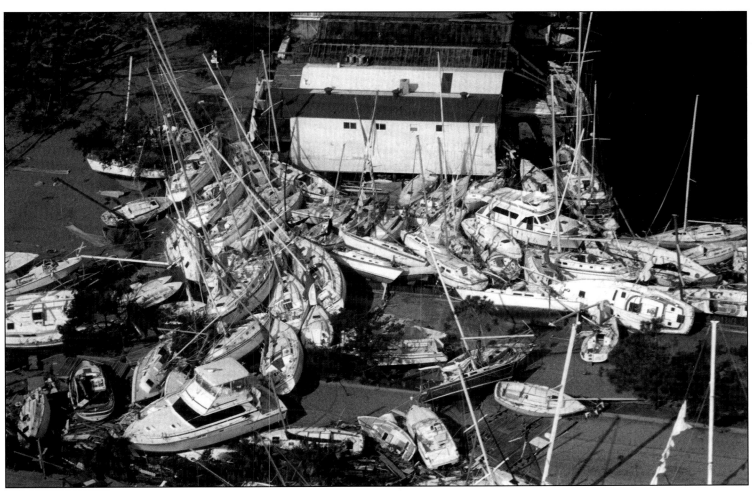

At a marina on the lake, boats once worth millions of dollars
resemble a haul of dead fish.

To All:

Everything comes full cycle, first the storm, downed trees, a real mess, then the military cleanup and removal, things were looking pretty good, now the residents are coming home and the place is a mess. Piles, I'm talking huge piles of stuff being pulled out of houses and stacked along the curbs. Six-foot-high stacks, millions and millions of dollars of home furnishings, carpets, rugs, sofas, draperies. You name it I've seen it.

Now since I've got A/C someone gave me a six pack of beer. My one luxury is now in the evening I drink one beer. Boy, does it taste good. I'm not sure if it is the brand or being able to drink it in a monastery. It sure tastes good!

An adjunct to that is, Walker and I play a mean game of bottle cap hockey on the linoleum floor in my room. She slides, gets and passes the bottle cap with speed and grace. Leaping over, under and around the furniture and bed. She even now brings the bottle cap to my feet, dropping it, letting me know it is time to take a break and play.

I was at the 17th and London Street canals again. To this untrained eye, it sure appears that the levees failed because of poor design, construction or maintenance. Sure wouldn't want to be sitting on the Orleans Levee Board right about now. As a matter of fact I haven't seen hide nor hair of the President. Wonder if he is still around? Remember I'm just the photographer, by the time the high-priced Philadelphia lawyers get through with all of this, they may convince the world that it was me that caused all the flooding. I know I'm

standing there seeing it with my own two eyes, but I still have a hard time believing how these houses were moved around, pushed off their foundations, floated into each other and into the streets. Entire sides of a building sucked off, two-story houses reduced to one story. The smell, the flies and the strange sounds are everywhere.

On the way back from the canals I came across the helicopter that crashed. A big beautiful red copter lying on the banks of Bayou St. John, again just another surreal experience we call Katrina.

A north breeze greeted me on my run this morning, cooler, drier air was the order of the day. Autumn can't be far behind. I'm losing the stars as the power comes on and the ambient light fills the night sky. I also realized my days in the Monastery are numbered. I sure hope I can remember all that I saw and felt during my time here. Such an amazing time.

Looks like ants coming to a picnic, the stream of cars coming home! We have been murder free since the storm, I think. Probably the longest break in recent history. Sadly I wonder when the first murder will take place. Oh I wish we could lose the title of one of the most murderous places in the U.S.

Next on my list is to go down to the Industrial Canal and have a look at the barge that punched a hole and flooded that area.

More later,
David

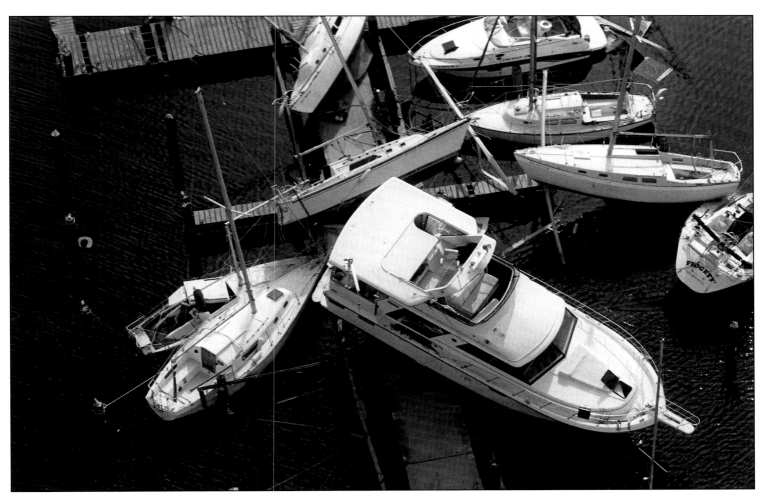

Large pleasure crafts were tossed like Styrofoam cups.

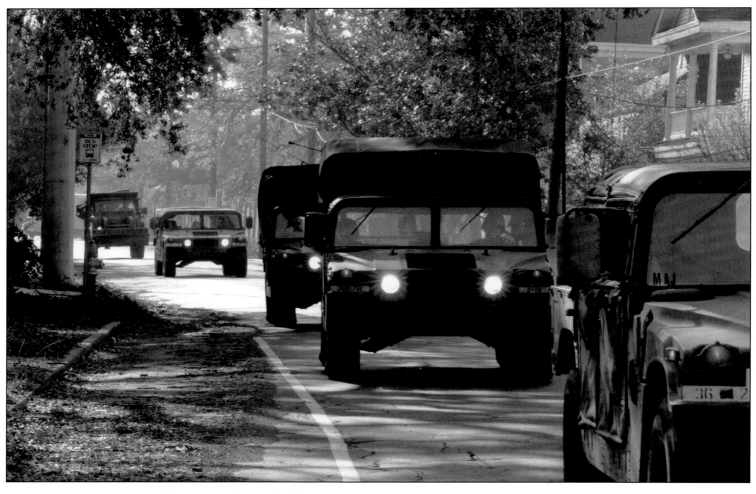

The National Guard rolls through the Garden District on patrol, providing
the city with a needed sense of order.

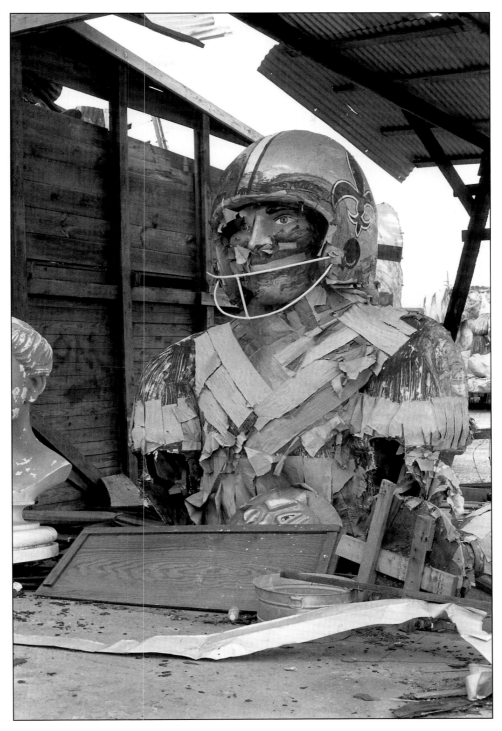

A float head stands defiant.

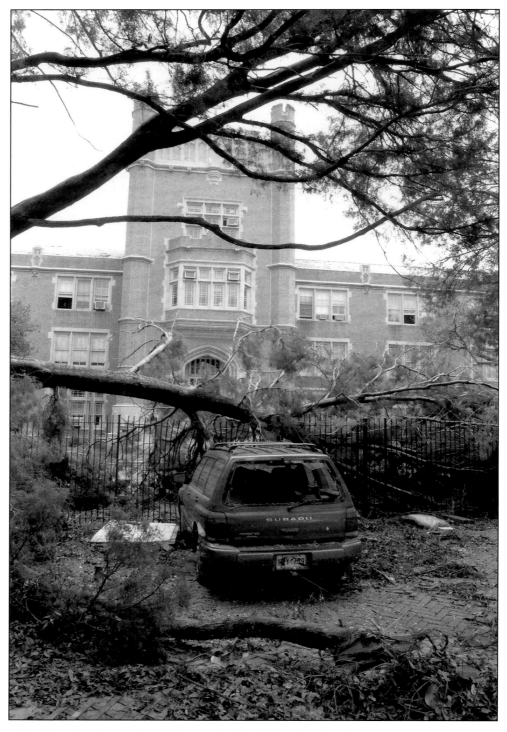

Ursuline Academy, the oldest Catholic girls' school in the country, was heavily damaged by wind and water. The sisters and those sheltered with them were rescued by boats and helicopters.

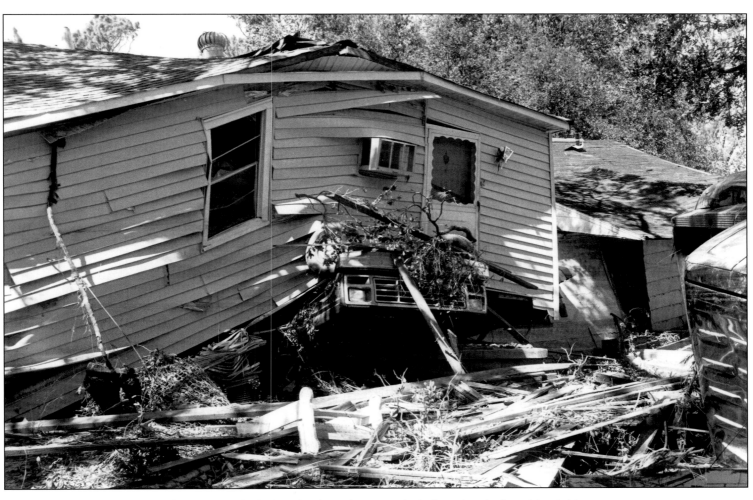

The Lower Ninth Ward, when dry, revealed almost unbelievable sights,
like this house that floated on top of an overturned truck.

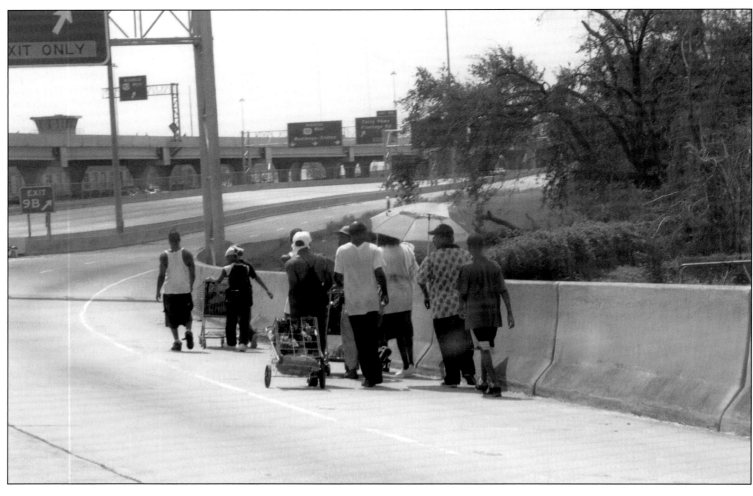

Evacuees flee the city any way they can, some only to be greeted on the other side of the Mississippi River bridge by gun-toting deputy sheriffs.

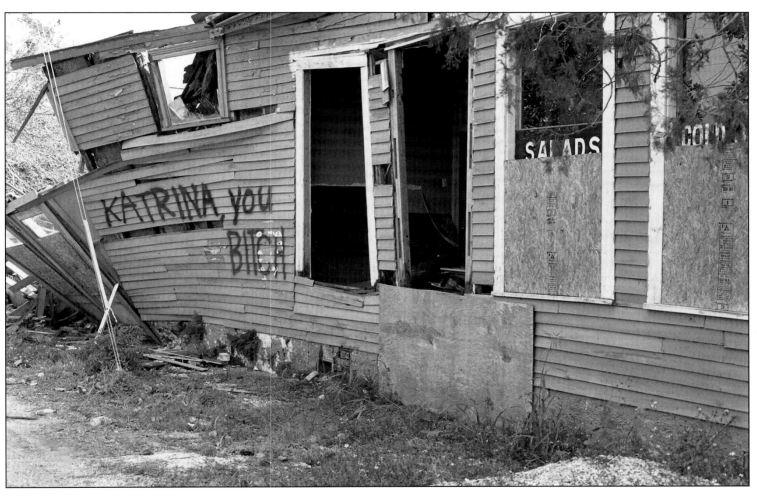

Where Magazine Street turns into River Road, what was once a neighborhood store and sandwich shop shows the destruction and rage caused by Katrina.

II

Living and Working under the Radar

Alone most of the time trying to process what was taking place, I would wander as far as I could. Still without regular communications, I developed a network of friends and sources that gave me the lay of the land. Cell-phone calling was hit-or-miss, so during my explorations I would gather the latest news from the street. Rumors were common, and I quickly learned how to factor the information. My goal was to stay out of the way and out of sight as much as possible. The mayor, the police, and the military didn't want anyone here. I was challenged at every checkpoint, even with my press credentials. With the reports and sightings of looting, I kept my comings and goings irregular because I didn't want anyone to see a pattern in my movements. A cat-and-mouse game but with serious outcomes if not played seriously.

In early October the *Times-Picayune* ran an extensive story by Angus Lind on the convent and me as acting care-taker. The article raised concern for the nuns among the New Orleans community. I was stopped often and asked, "Have the sisters returned? How are they?"

The media had descended in full force. Canal Street was lined with transmission dishes and news personalities moving about in their latest disaster gear. Gas tankers and trucks full of water were everywhere, not for the citizens of New Orleans but to keep the news crews cool and quenched.

What was starting to affect me was the new destruction that was taking place. The storm was long gone. The water was leaving in some areas. But each day there seemed to be more fires breaking out all over the city. The fire department was doing the best it could without sufficient water pressure. It was happening everywhere. Large and small houses and businesses were burning. Landmarks, family homes, schools. And so it all continued days and weeks after the storm.

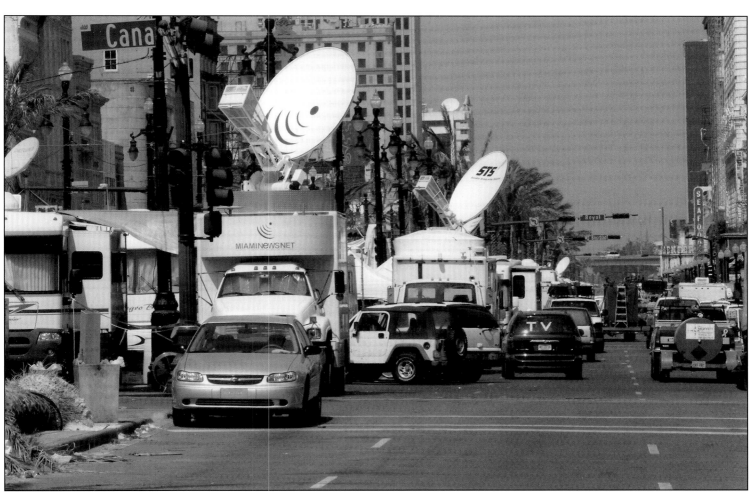

Canal Street becomes media central for the world.

To All:

End of the month, end of the third quarter, wonder how all this Katrina stuff is going to work on the economic numbers? Lost conventions, thousands of meals at our wonderful restaurants. Someone a lot smarter than me pointed out that lots of these businesses have business interruption insurance, so why are they going to bust their butts to get open if there aren't any customers? Interesting, if the conventions have canceled, tourism is off, why be the first on the block to be open. Wait as long as the policy allows. Why open a dinner restaurant when we still have a curfew? Of course little potatoes like me don't have anything of the kind. If I don't work I don't eat. Hunger is my great motivation!

Let's see, today is Saturday, a long run with the gang, flash, I was joined by Gerald, the second runner to come home to the park, then cut the grass and off to the laundry to get my starched shirts, pop in for a large coffee and a scone. Down to the gallery for a little work, catching up from the week's activities . . . NOT. Nothing much is open. Garbage bags full of my icebox goods, pre-hurricane, still sitting on the curb. Short pants and knit shirts are the uniform of the day. In serious need of a haircut. Haven't found a grocery open, there are a couple of drugstores up and running. Cobblers, alterations shops, jewelry stores, clothing stores, nope not open.

Down in the Industrial Canal where the barge broke through, again total destruction. I found beautiful plates and cups stuck in the mud, photo albums water-soaked and half-covered with mud. I know, I know I sound like a broken record, but it is true, all these areas are alike but different. I keep thinking about all the lives twisted and turned upside down. The pictures are the same but very different. The textures of the houses, the shapes and angles, the light of the day creating different moods and feels. I saw two bathtubs resting next to each other. On one side of a block two bathtubs find each other, of course I took that picture.

One of the sounds that has been part of my life for the last month has been the helicopters flying overhead. Lots of military ones, all the different types, the news media flying and shooting the story. At night the ones with the big spotlights looking for those bad guys. Very strange having that air activity so low and close at hand. I was told that during the first days after the storm that 75 to 100 helicopters were flying, plucking people from rooftops, bringing in supplies, filming the story. Even now very few commercial airplane flights overhead, just helicopters. Every once in a while the low-flying planes spraying for mosquitoes.

Watch a little college football and drink a beer for me!

More later,
David

To All:

Alert the media, I'm wearing big boy pants! I'm escaping Orleans and headed north to Covington to attend Mass at the Abbey and receive Holy Toast. I will see Shelley and Sasha! Just for a few hours out of the belly, as I've got a 3 P.M. assignment back here where time stands still!

A very quiet Saturday, did run with a friend, seeing more and more friends wander into this never-never land. My cousins Jeremy and his brother James flew into town for four hours to clean Jeremy's icebox and apt., donning hazard waste masks they got for the task at hand. Jeremy being a recent grad of Tulane, we all know that most of the hazardous waste wasn't caused by the storm, just that good old college living. Great seeing the two of them for a brief period. Can't

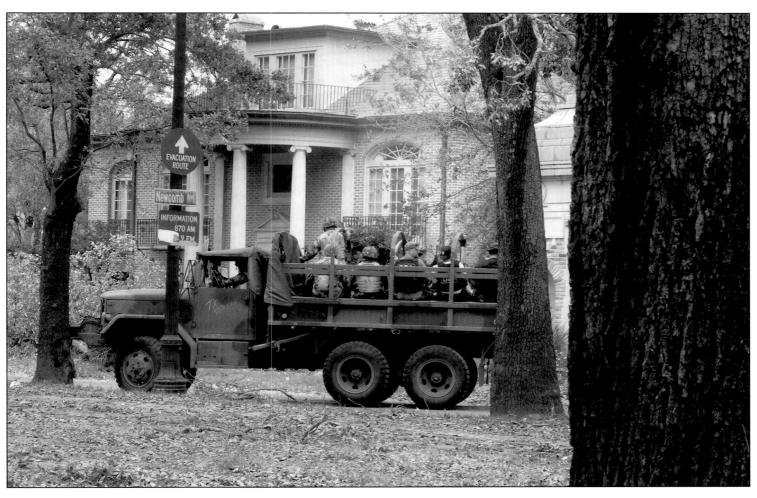

The National Guard patrolled throughout the city
to discourage and stop looting.

wait for Jeremy to get back to N.O. All the other newcomers wandering around looking, the questions, the disbelief is written all over their faces. They have a hard time believing that I've been here for most of it. They are distraught that CC's, PJ's, Starbucks aren't open and ready for THEM. If they only knew. Still not much new to report on the opening scene. Still no gas stations, groceries, restaurants and most or worst of all coffee shops in the Uptown area. If I go postal it is cuz I haven't had enough coffee. That is my defense.

Went down to the main post office, figuring that they of all people should be open by now . . . WRONG, so what about that "through wind, snow, blah blah blah," guess their union got that removed from the contract. Fed X, UPS are working, not the US Postal Service, guess that is yet another example of private vs. government! Just my jaded view of my little slice of the world.

Enjoy Sunday, know that I'm thinking of you!

More later,
David

SUBJ: Mon. 3.x.05 Day 35

To All:

Yesterday was a red-letter day. I discovered canned tuna, where have I been? Straight from the can, don't want to think about the dolphins, with a little salt and pepper, with a saltine cracker. Wow, what a treat, I'm ready for another thirty days. Forget the MRE's, give me peanut butter and canned tuna. Remember what I say, "simple taste for a simple mind!"

A good part of Sunday was just that, enjoying Sunday, Shelley and Sasha are fine, as well as her folks. Boy, Mandeville and Covington are suffering from major traffic problems, guess that is caused by the Katrina influx of people.

Almost didn't make Mass because the traffic was like rock concert bad, or maybe game day bad.

The rest of the day was spent talking with a French film crew here, doing some documentary work on the aftermath. Wanting to talk with and to people who will want to help rebuild N.O. Looking at our treasures and trying to find a way to get them up and running and drawing back the world travelers who are such an important part of our being. Really interesting to hear how we were treated in the world press. It was strange sitting and talking in the French Quarter, talking about the future and the smell of rotting food still hung heavy in the air.

This week promises to be full of new corners to turn. Lots more folks returning, many realizing how difficult it is to pick up the pieces after a month. I've got assignments in Baton Rouge and somewhere else out of the city. Dreading them as the traffic is awful with all the work crews and others coming home. Not being able to judge travel time is a drag.

More later,
David

SUBJ: Tues. 4.x.05 Day 36

To All:

A new moon greeted me on my run today, even without the moon I'm losing my stars. As folks come home and light up their houses I'm losing the night sky. There for several weeks, while the city was in total darkness the stars were there just above the treetops. I could see the shapes of the trees and houses as they were being lit by the stars above. I'm a lucky one to be able to see this beautiful city by moon and starlight.

More and more people are making their way back home.

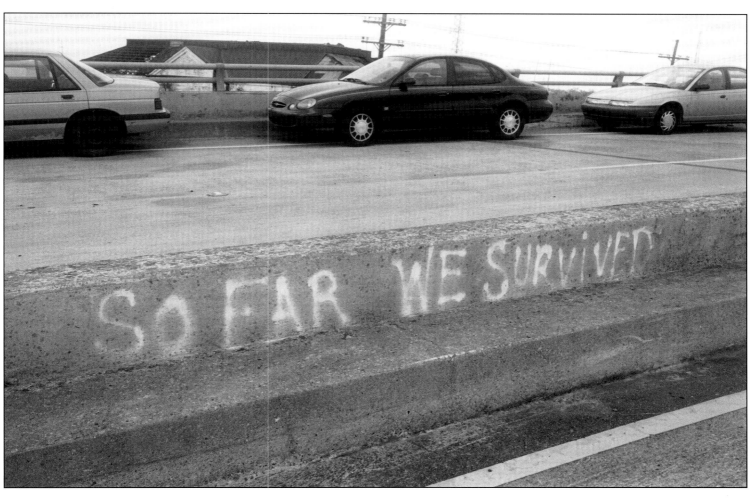

Atop the many overpasses used as rescue points, messages were left,
speaking volumes about the hardships and suffering.

Amazing the different places the winds of Katrina blew our citizens, all the way out west and back east, here and there. Yet the city is still very quiet, at times during the day the streets are almost empty, only a handful of places are up and running. We have a filling station at Magazine and State, still no word on the drinking water. Just remember what W. C. Fields said, he didn't use water in his drinks because fish F—— in it! Sorry, sisters!

They are supposed to be building a temporary housing community up in Baker, LA, just north of Baton Rouge, I really want to see and shoot it. I have visions of it looking like those camps that were built during WWII. Sort of a WPA for 2005.

There are parking lots full of water-damaged cars, deposited there by the city, getting them off the streets. Amazing how many of them have had their gas tanks emptied and windows broken. The other day I saw a hearse in front of a funeral home with a broken window, gas cap removed and the markings on the building informing the world that there were three dead bodies found inside. Plus the door of the funeral home was busted in!

My assignment in Baton Rouge was put off until today, I drove all the way there, the traffic was awful, as I was finding a parking spot I get the call . . . could we do it tomorrow? Of course, nothing more fun than driving all that way for nothing. On the road all you see are the out-of-state plates of those coming down here in hopes of finding work to help rebuild. Oregon, Maine, Montana, Missouri, New York, Oklahoma, I'll bet you could find almost all fifty states within a day or two. Hundreds of Latin workers who have been rebuilding Florida and its four hurricanes last year, they have moved over and are carrying a huge load of the work.

Off to Baton Rouge again!

More later,
David

To All:

Well, you know how sometimes you have good days and sometimes not so good, yesterday and the day before were not so good. I had what I thought was going to be a simple and interesting assignment in Baton Rouge on Monday, arriving in the capt city, parking my car on the LSU campus I get a call from my BR contact person for the assignment, "oh, by the way, we have put off the shoot until Tuesday, same time, same location." Ahhhhhhhhhh OK, Ahhhhhh guess I will turn around and drive back to N.O. I'm a big boy and this happens on occasion in my business but usually I feel like something out of my control or the client's happened. So, once again I drive to BR, again the traffic is awful and worse once you are on the surface streets in BR. Sitting in the room, on LSU campus, at the appointed time, no one is there. Waiting an extra ten minutes I give my contact/leader/girl a call, get her voice message. Now I'm really not happy, leave her a message and ask her to call. A few minutes later, she calls, oh, this time she had tried to call but got "dead air," her words. I wanted to explain, "what is your point" there has been this thing called Katrina and all the cell phones are screwed up. It is the misconnects, dropped calls and bad reception that drive me mad. So her one try and getting dead air didn't sit well with me. She now tells me that the photo op is going to take place at 6 P.M. north of BR. Of course being a middle-class sort of guy, feeling like I've come this far I'd better stick it out and get the job done, I say OK. I do call my assignment editor in NYC and fill her in on all the foul-ups. Pointing out now I will return to N.O. after curfew, not something I'm real happy doing. In turn she calls the publisher of the magazine that this picture is for and tells my story. Out of the blue my cell rings and it is the publisher

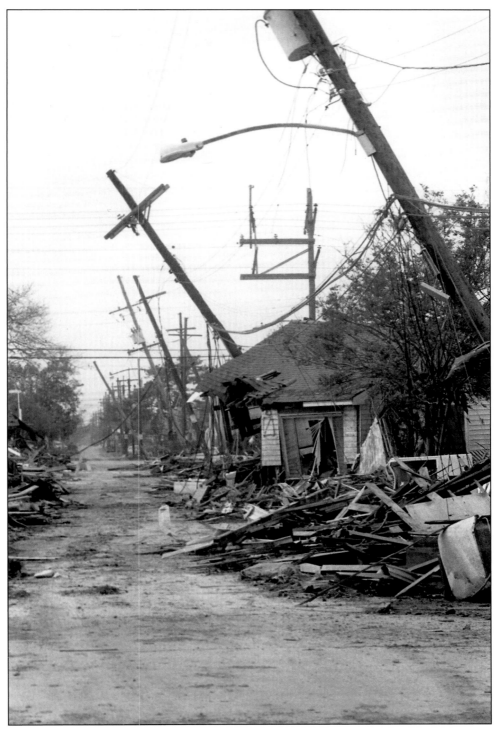

A street in the Lower Ninth Ward is unrecognizable from its
preflood appearance.

expressing her deep heartfelt regret, which I believe. Then she tells me that because of the problems that I have had and the possible problems with curfew she wants to "kill" the assignment with full pay. I told her no, I had come this far, I was going to shoot the damn assignment, transmit it to her. I don't like getting paid for something I don't complete, that Okie upbringing I guess. If she wanted to kill the assignment on her end after getting the images, fine, that is her decision. But I'm doing the job.

To add insult to injury, the assignment was nonplus, the image will work but won't be anything close to what I was hoping for. Sometimes things go South and you can't do a thing about them. I didn't even get a good cup of coffee out of this trip!

There is always tomorrow!

More later,
David

SUBJ: Thurs. 6.x.05 Day 38

To All:

I figured something out. The last three days haven't been great, I think I know why now. We are entering a new phase of Katrina. The first was the storm, second was being without power and under National Guard, not a bad thing, then the power returns, still not many people. This phase is power is coming up, people are returning, businesses are reopening, and I'm leaving and reentering New Orleans. What makes this disturbing is that Metairie, Kenner, Baton Rouge, Covington and Mandeville and others are so much further along in the process. Metairie is almost normal, normal as far as Metairie goes, crazy traffic, strip zoning but lots of stuff is open. I think you get the picture. Right now I'm liv-ing between two worlds, Katrinaville, New Orleans, which is still very much dominated by the storm and let's say Metairie which is a lot further along the road of recovery. Driving around N.O. you are always looking over your shoulder, still seeing the effects of the looters, nervous and weary. Stoplights that don't work, National Guard units riding around in convoys, large, I mean huge trucks driving on St. Charles, no streetcars. New Orleans isn't right.

Now I have choices, Winn-Dixie on Tchoupitoulas is open, Sav-A-Center will be very soon if not already, I don't have to eat peanut butter or tuna. I can go to a store and buy other stuff. I can go to Metairie and get my car worked on or even washed. Our old way of life is returning. Glad but sad, now all my bills come due, writing checks will become part of my day. Telemarketers will start calling!

I'm not suggesting that Katrina is done, far from it. As a matter of fact she will be with us for years. I'm sure we will start referring to things before and after Katrina. But the everyday things will start creeping back into our schedules. We're losing something, yet gaining something else. I know that for the last three days I've been shooting just commercial work and I really miss driving to different parts of the city and shooting pictures of the story of Katrina, I'm afraid I might miss something. Something that I've lived with for over a month, sometimes very much alone. Wandering the city, wondering how this storm wrecked and ruined lives.

A different wind greeted me for my run, the morning sky is changing, I understand a cool front is making its way down yonder, you can feel the change in the air. Everything is changing!

More later,
David

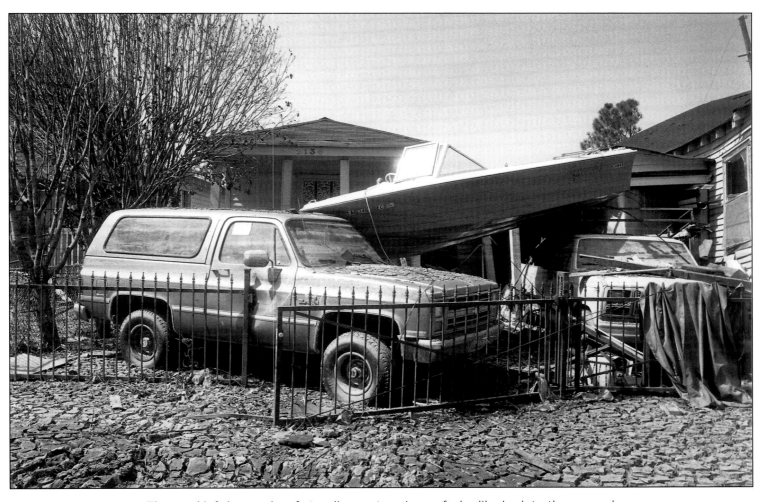

The mud left by weeks of standing water gives a fudgelike look to the ground.

To All:

Flush, the City of NO announces our water is safe to drink, that is good news. For the last 25 years I've been drinking bottled water, so I guess that means the water is better than before Katrina . . . Right, if you believe that, I've got some land down in Arabi you might be interested in.

Another strange occurrence today, I was interviewed by a French documentary film crew. They were wanting to get the point of view of some artists. People who stayed through the storm, painters, writers, musicians and a token photog. I'm sure if I make the final cut, the French viewing audience will be forever glad they sold this piece of questionable land to Thomas Jefferson.

The rest of the day was spent editing images and burning them to Photo CD's, preparing them to be shipped. The client called and said they needed the images in NYC in the A.M. would I just Fed X them to them for an early-morning arrival. Knowing UPS and Fed X's service is very limited I told them I would have to get back to them on if this was going to be possible. They were stunned, a world without overnight service how soooooo backward. After long and trying phone calls my choices were two. Drive to the airport or to a drop box in Metairie. Metairie wins and so does UPS, thanks Brown.

Driving back, talking with my assignment editor, he still doesn't understand the difficult conditions we all are working and living under. And the truth be told he may never. So it goes.

More, a few more folks out and about, the sounds of repair everywhere. Hammering, chain-sawing noises can be heard all over town. Downtown is a mess, huge trucks blocking streets, clean-up crews everywhere, windows being replaced. Canal Street is a parking lot with everyone parking wherever they can find a spot. These newcomers must be putting out their spoiled piles of food as the rotting smells are back and very strong.

North by Northwest, that is the direction of today's wind. My weather cat Walker was up most of the night enjoying the approaching cool front. The heat of a very long hot summer has been broken. Racing clouds, swaying trees, a head wind as I run toward St. Charles adds a new and pleasant dimension to the park and my run.

More later,
David

To All:

Amazing what a cool front does to one's mindset, Friday was beautiful and with a north wind there were times when you didn't smell the spoiled and soiled garbage. The change in the weather lifts the spirit and for brief moments during the day you could forget about the recent past and put out of your mind the punishing future.

Good guy and great friend Larry O. M.D. came by and after a good visit we went out to lunch, yes, out to lunch. A first for me in over a month, of course the main course of conversation was Katrina but you could overhear talk of sports, duck hunting and a variety of other topics. Even saw one fellow in a suit, another first in over a month.

Even the number of calls from the photo agencies are slowing down, they are looking for and waiting for the next disaster. Sure hope it occurs a long way away from here. I'm going to start traveling around some of the other hard-hit areas such as the Gulf Coast. I'm also going to revisit many

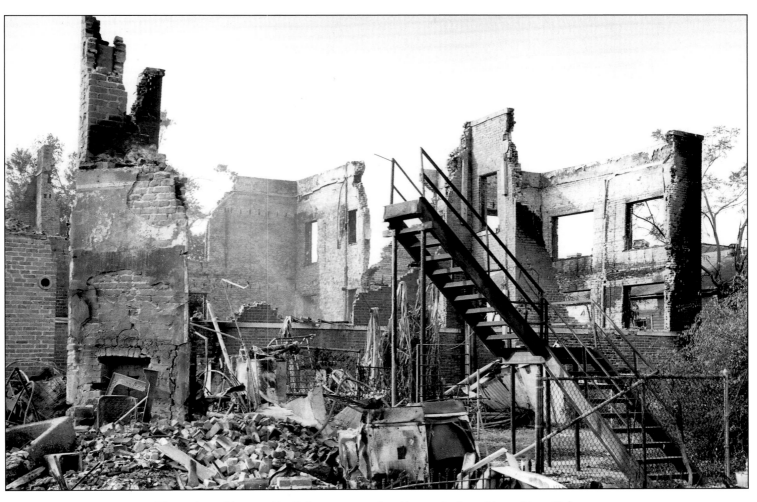

The ruins of burned buildings are a ghostly reminder of how New Orleans
became a completely disabled city.

of the areas that I've been photographing as I want to follow the process through. See how and what will happen over the next several months and years.

Guess you've heard the Mayor has come up with the quick fix, Gambling. Let's not make some hard and long-term changes, let's put a Band-Aid on this deep wound. Guess you can tell I'm not pleased with his first proposal. Well, I'm not, not that I'm opposed to gambling, I'm not. I just think N.O. has a lot more to offer, why should we want to be like Las Vegas or Atlantic City, without gambling they have nothing. Without gambling N.O. is still one of the most interesting cities in this country. Shallow thinking gets short-term results. Quick fixes put us on thin ice, where we have been for over a quarter of a century.

Temps of 66 will take your mind off hurricanes pretty quick. Wow what a wonderful morning here in Katrinaville. Maybe Jimmy Buffett will write a song about us. Someone told me yesterday that Katrina means cleansing, if the truth, pretty amazing, I would say.

I got a call yesterday, the Sisters, my Sisters, your Sisters are coming back on Thursday. Can't wait to get them home where they should be. The phone at the Monastery has been ringing off the hook, I'm sure people are wanting to see and hear from them. I know they have been missed.

More later,
David

SUBJ: Sun. 9.x.05 Day 41

To All:

Really am starting to emerge from the Katrina State of Mind, I feel confident enough to take the flashlight out of my camera bag. I'm no longer riding around with a five-gallon gas can in my car just in case I find some fuel. I'm even remembering to turn ON the lights when I walk into a room.

Yesterday I did a picture of this lady, this is what makes N.O. so amazing, who has gathered up 105 ice boxes all left on the curbs. She has cleaned them, has them standing in her front yard. A modern, very 2005 Stonehenge, well maybe if you have a vivid imagination!!!! Her plan and hope is to ship them down to Honduras for the folks down there. Personally I've been looking for a sub-zero fridge on the street, so far no luck!

Also yesterday afternoon I went north to see Shelley and Sasha, what a nice way to spend Sat afternoon. Cool air and a three-year-old laughing and playing. Stayed for dinner and while driving back a setting moon, waxing moon I guess, lots of orange in it so our next full moon on the 17th should be a harvest moon.

While driving after a wonderful day I got very sad thinking about Nagin's out of the box thinking and plan. If this is the best he can do we've got bigger problems than Katrina. Here we are at a huge crossroads, we can address education, crime, business and housing and his vision is gambling. I really have to wonder if there is a future here for a small potato like me. Sorry for the downer but I am very concerned!

Now one of the best things I did during the blackout period was reread a great book. Sonny Brewer's "The Poet of Tolstoy Park." Reading it by candlelight made it even that much better. The main character Henry Stuart and his life in Fairhope AL, building his round house, surviving a hurricane. Please read this book, a real treat! Sitting there trying to not sweat on the pages and the flickering candle made it a slow go. What great fun. Not long before the storm, Sonny was in N.O. with Rick Bragg doing the audio version of the book, so I got to tag along during some of the sessions, shooting pictures of two, they are two of our best, Southern

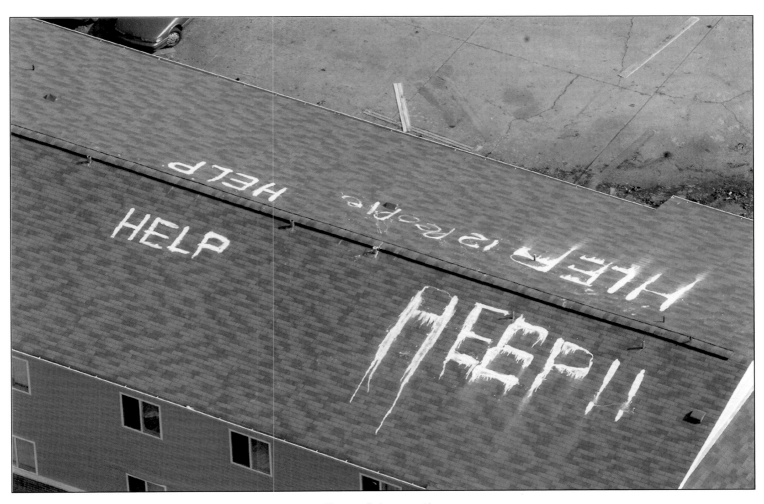

Signs of desperation

voices. Rick's voice, Sonny's words sure provided me with some great pleasure and wonderful images during a very dark time in N.O. Lucky me!

More later,
David

SUBJ: Mon. 10.x.05 Day 42

To All:

A very nice Monday, cool, clear and still light traffic! Seeing some activity but still is very quiet. People are withholding judgment as to the future, a real wait-and-see attitude is forming. From my real estate friends I hear there are lots of listings, not sure how many buyers. Lots of interest in short-term rentals.

With the Sisters returning Thursday this is a real nice break point in the drama of Katrina. I'll move back into my house, Walker will be sad to leave the Monastery as she likes being on the second floor and seeing birds up close. I'll miss my daily tasks of checking on and moving around that beautiful house. Sitting in the kitchen drinking a cup of coffee, windows open, the quiet of the morning. Heading back upstairs to bathe and dress for the day. Spending time in the chapel, ringing the bell and gathering my gear and heading out for the day. During the period without power it seemed like it would never end, now it seems it went by so fast.

Yesterday while having a late lunch at the new restaurant on the corner of Wash and Mag with Shelley we were greeted by four NOPD, a little strange but these are strange times. Ordered lunch and having a nice time, who should walk through the door but Mayor Nagin, as mentioned before I've met and know him, we spoke and when asked how he was doing he said he "never signed up for this," a very telling comment and a sad one at that. Much later it dawned on me the four NOPD guys around the front door were there in preparation for his walk through.

Later, we were out driving and saw Frank S., stopped to say hello and see how he was doing. He walked us through his once-beautiful home, nine feet of water, everything destroyed, yet there he was standing at a once-beautiful desk going through thousands of photos, most if not all ruined. Hoping against hope to find some that were salvageable. There he stood, he said something very true and enlightened, yet very sad. He said going through these photos of his life was "like attending my own funeral." His words will stay with me forever, as this is how most will probably feel when walking back into their homes. There they are on the outside looking in!

More later,
David

SUBJ: Tues. 11.x.05 Day 43

To All:

Driving to the gallery I stopped at the French bakery on Magazine just above Napoleon, the place was packed, they now have tables on the sidewalk and are serving coffee. Lucky me a cup of real good French-style coffee and an apricot Danish. Woooo baby that is living! Seeing old faces and some new, almost feels normal.

Yesterday's assignment was to shoot an 18-wheeler of donated school goods from Target to West Jeff High School. After practice the 50-man football team came and unloaded the truck with amazing speed. Of course 50 high school football players provided some funny, very funny moments. All mugging for the camera, pushing and shoving each other as only HS boys can and do, very uplifting. The assistant principal who had made all the calls trying to get the school

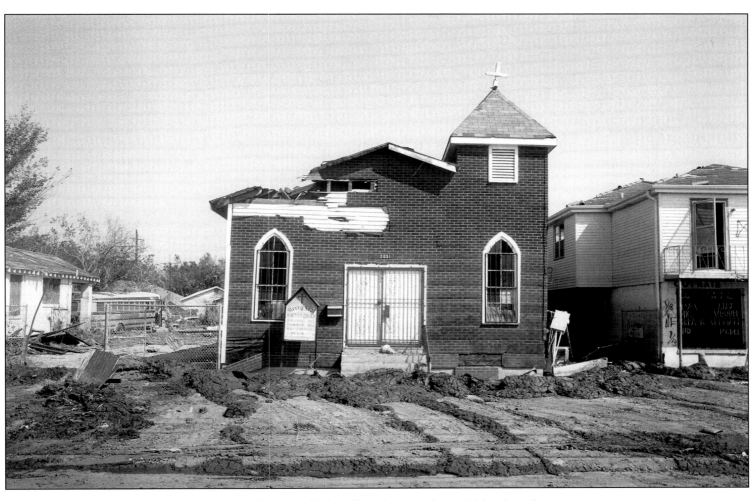

Most of the small churches dotting the neighborhoods
of the Ninth Ward were destroyed.

supplies was overwhelmed by Target's response. There is enough stuff that she is going to share it with some of the very poor grade schools in the neighborhood. Her efforts were her own, taking the bull by the horn and all that stuff.

A few more runners and walkers in the Park, ran with good friend Bruce W., shared stories, wondering and trying to figure out the future of this place. Being such a small part of the community and not having much knowledge of the inner working of big business I'm doing lots of listening. One conclusion I've come to is, it isn't going to be an easy and quick fix. This is so huge, I've been over most of the ground around here and I can speak with some authority, the physical damage is beyond anything I've ever seen. We're not talking months but years. It is really hard for me to get my mind around this, on all levels we are in trouble, little guys, big guys, schools, businesses, services, medical, if you can think of it, it is probably in trouble. So of course I run hot or cold to the future of our city. Another thing I'm convinced of is that I'm not going to make a quick decision on anything. Taking a long view is my plan, let some of the dust settle, let cooler heads prevail and make some short, medium and long-term plans.

Dropped by the drugstore yesterday. As I was walking in a friend stopped me and congratulated me on the TP story, while there talking who should walk out but Angus L. the writer of the story, introductions made. Now a third person walked up and asked if I was David Spielman, saying yes, she said she loved the article, introducing her to Angus we now have a small group blocking the entrance. A woman walks past, enters the store, pauses, comes back out, asks if I'm David Spielman, now everyone is wondering what is going on. She tells me she has been receiving my e-mails, so of course I ask who she is, never met her in my life, complete stranger. She tells me that Jim H. of Birmingham has been forwarding them to her. She and her husband bought Jim and Ann's old house here in N.O. and they are staying

in Jim's lake house in Alabama. So I guess that is my fifteen minutes of fame. There on Tchoupitoulas on a Monday afternoon, I had to laugh driving away, how this storm has pushed us all around, yet reconnected us all in some way.

Mail service is back here at The Rink, it is nice to be missed, all my bills are due and my suppliers missed me. Of course those who owe me money haven't managed to send their checks. So it goes, the exciting life of a freelancer!

More later,
David

SUBJ: Wed. 12.x.05 Day 44

To All:

Yesterday was in the Lower 9th again, have lost count of the number of visits to Katrinaville hell! Got to the second break in the Industrial Canal, I'm trying to figure out how many houses got washed away, it has got to be almost a thousand, seeing me write it makes it even harder to believe one thousand homes washed away, but if you do the math and that is one of my many weak subjects, it has to be very close. You can't even figure out how many houses sat on one side of a block. Did see a house sitting on top of a pickup truck. Saw two cars on top of each other, looking like two frogs mating.

One of the strangest things was on the next block, a two-truck caravan of the Red Cross, going street by street, block by block offering hot meals, water and fruit. No one was there. Surreal! So I drove around and shot some pictures and talked with them. What an amazing organization, all volunteers, there they were trying to feed and help whoever, they had found some Entergy workers who were hungry, some of the crews rebuilding the levees. These guys were from Kansas, Arkansas and they were almost speechless at the condition of the area. I know that when they head back home, no one, no one will be able to understand fully what they have

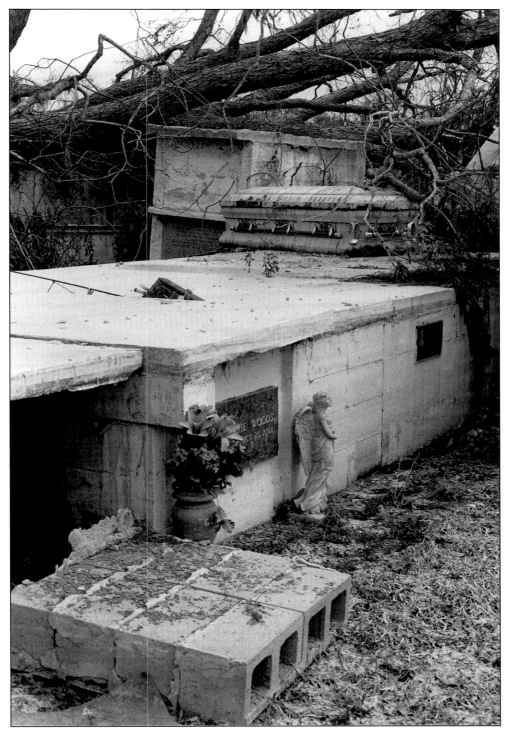

At a rural cemetery downriver from Chalmette, even the dead
were subjected to the wrath of Katrina.

seen and felt. Our language fails us when it comes to words that describe what has happened.

I also saw a regular army guy from Calif. and his uncle standing in front of what used to be a house. I had to ask, was it the uncle's home, no came the answer it was the grandmother's home, she was, I think, in Jackson, they were discussing that she should not come back and see it as it would be too much for her. They were trying to figure out where the tree that was now resting on the fence had come from. They were trying to find the back part of the house as it had broken free from the rest of the building. They were pointing out where the driveway was, the porch and her little garden, well, I couldn't see it, nothing was there, but these two could see it, I'm guessing in their mind's eye. Yet another sad tale of Katrina, how can you capture all that in a photo, you can't.

Today, I'm off to Lake Charles, sadly I've got to drive through BR, traffic is beyond awful, the assignment is a group of transplanted N.O. folks moving into a new house over there given to them by a group of folks that could! Nice story!

More later,
David

SUBJ: Thurs. 13.x.05 Day 45

To All:

It was my last night in the Monastery, the Sisters are coming home this evening! Can't wait to let them in their own house. For most of them I'm sure this is the longest they have been away from here. Far too many things were running through my head to get much sleep. Wanting them to find their home as they left it, I'm afraid my plant-keeping skills are pretty weak so we lost some green stuff around the house. Remembering all the adventures of the last 40-plus days. Of course the heat and lack of sleep, gunshots in the middle of the night, going for days with just seeing the Guard, all of that visited me last night. Pleasant thoughts were there as well, moving around the house by flashlight, eating peanut butter sandwiches for breakfast, reading Harry Potter by candlelight, that I recommend very highly, really adds to the magic of Hogwarts and all the gang. Windows wide open and the night noises, nothing else entering in my ears but the bugs and birds talking. Oh, the stars and my favorite the moon, they were all here and all mine for a brief period.

Things I've learned, well just a few as the list is long and diverse, you can wear the same clothes all the time. I wore one pair of shoes the entire time here, two black knit shirts and one white one and two pairs of shorts. I guess I'd better retire my uniform. Handwashing laundry every night, it took two days to dry so every night I had to do laundry. Speaking of laundry I'll bet not many of you can say you've handwashed sheets, I'm not recommending it, as it is a real chore. I figured out how to string a line on one of the upstairs balconies, so I did my wash and hung it out to dry. It was so hot and sweaty at night, so sheet washing was a twice a week event. How without all the tech stuff we have grown addicted to, you can still live without power, or at least most of it. I learned more about the power of looking, noticing. You knew if someone had been around your place, or if one of the houses you were watching had visitors. I really want to write more about this later but for some reason these random images were running around my head last night.

Driving across Louisiana to Lake Charles drove home how much everything has changed and will continue to change. Traffic through Baton Rouge moved at a snail's pace. I've heard that over 100,000 folks from N.O. have relocated there and some say most might stay for good. The hundreds

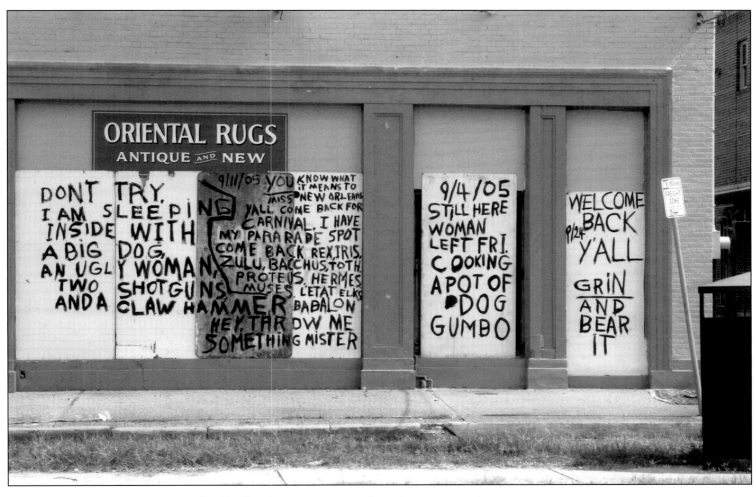

A St. Charles Avenue rug merchant keeps a running commentary
on the front of his store.

of trucks heading our way loaded with lumber, generators, temp housing and tons and tons of other materials. Thinking of just how long the rebuilding will take. First the sugar fields of the Lafayette area and then the rice bowl further west, this is a diverse state, beautiful too. The traffic was awful going and coming, I'm still seeing lots of small trucks, vans with out-of-state plates from faraway places heading here to try and get some of this work. Men and women who want to work, roll the dice and head south betting that somewhere, somehow they will find work. Counting on their skills and will to make it happen.

More later,
David

SUBJ: Fri. 14.x.05 Day 46

To All:

The girls are back in town! The Sisters arrived just before dark last night, road weary and very tired. As they got out of the car you could see and feel their pleasure at being home. Their hugs and tears were coming from their wonderful hearts. The whispered thank yous and them telling me that this is the longest the monastery had ever been closed added to the importance of their homecoming.

My cooking skills are extremely weak but I promised I would have food, so one of the two things I cook I prepared. Cold pasta salad, wine and some ice cream and chocolate cake made by Shelley's mom was their homecoming meal. I had all the lights off as they left in darkness so I wanted them to return the same way, candles lined the main hall to the dining room. The table talk was all over the place, them sharing their adventure from Texas, me filling them in on all the goings on around N.O. George O. was kind enough to give some beautiful flowers, and the woman who owns the

flower shop on Magazine gave a beautiful centerpiece. Of course I've forgotten her name and the name of her business. Another nice touch for their homecoming. Sitting, talking and laughing, the house was filled with their joy of being home. The evening ended with me and Sasha ringing the bell one more time announcing their arrival. After the three peals of the bell they sang an Amen! As Shelley, Sasha and I left and looked back, the house was lit up, full of life, it had been so dark for too long. Big boys do cry!!!!

Off to my house for the first time in my bed for quite some time. Another restless night and still more images raced about, as this chapter is closing. This morning, wow, a shower and then standing in front of my closet trying to figure out what to wear. More than one pair of shoes to choose from. Walker found her rhythm very fast once we got back home. Running and jumping, ducking in and out of the rooms. Made coffee, read the paper, "ah good day in the hood" to be sure.

Tonight I'm headed back over to the convent as I'm going to cook for them my second meal, the other thing I can cook. Pizzas! They were so impressed with last night's effort they wanted a command performance. I was told, I am now referred to as Sister Mary David, kind of like it. I certainly couldn't be in better company! Lucky me!

More later,
David

SUBJ: Sun. 16.x.05 Day 48

To All:

Going to slow the pace down on these notes, as people find their way home and things start returning to normal, the news and observations will slow down as well.

Today I was interviewed by a documentary film crew

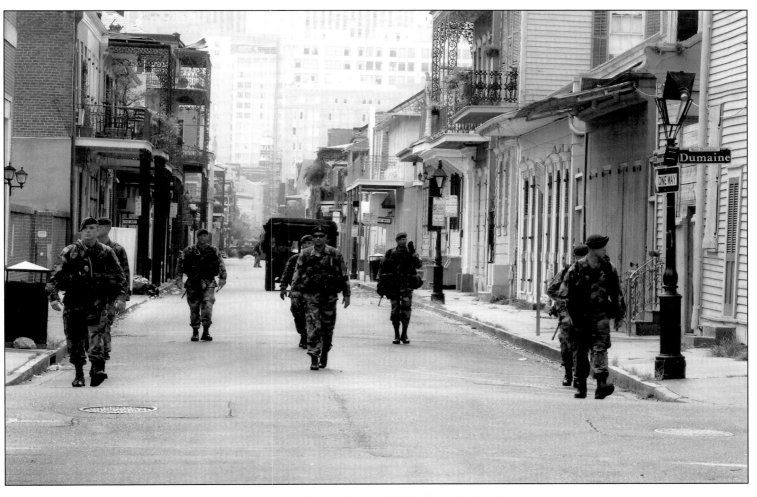

The National Guard patrols the French Quarter.

from the Univ. of Colorado. The thrust was how I got around and did what I do and my review on the media as a whole. I'm afraid the group did rather poorly. There didn't seem to be an evenhandedness in the news. The different media outlets seem to chase the same stories. An example, one day someone runs a piece on animal rescue, then for the next several days all we see and hear are stories about animal rescue. Not that it isn't a good and important story, but where are the independent thinkers, who go out and find something new and different? I also feel that if the media went out today and filmed Lakeview and showed the level of destruction among those upper-middle-class neighborhoods, the majority of the viewers might think the images were from another hurricane. Stories about middle-class folks following the evacuation order and having a total loss of their homes didn't make the evening news. Those who chose to stay and were being rescued by air and water were the focal point, of course we know why and what sells newspapers and TV spots!

Another point I would like to make is that I have a hard time looking at their images and not knowing if they are live or filmed days ago. There needs to be a method by which footage is dated and shown to us the viewers. It is misrepresentation when they are talking about things today but showing older images that aren't the way conditions are at the present. They are using images to reinforce their story line or point of view. That isn't news!

Now as interesting as today was, yesterday was another story. My assignment was to shoot a play day by Nickelodeon over in Baton Rouge for the families displaced by Katrina. Kids playing, having fun, singing, laughing and eating, now that was a treat. For these kids whose lives have been turned upside down, a few hours of nothing but fun. Hey, they even got to have their pictures made with SpongeBob and Dora,

not sure if I can fully understand the draw of those two, but what could be better for a kid, and they were crazy about it.

Sam L., my good and dear young friend, was in town packing up his apt., gathering his stuff with the help of his dad and aunt. Stan the dad is an old college friend of mine. Sam came down to N.O. to go to Naval Architectural School at UNO. Then fell in love, took a job, got married and they are expecting a baby, things were looking good. Then Katrina, living below the Quarter isn't the best place to bring up a newborn, so Sam takes another job up in Memphis, good for him, bad for us. Sam and his friends are the future of this place and losing him isn't good. There goes a long-term tax-paying family that would have contributed to the well-being and growth of N.O.

More later,
David

To All:

A full moon, 61 degrees and very low humidity, what a great way to start the day! Welcome to the incredible adventure of New Orleans the sinking shrinking city. One step forward and six back.

I feel like a yo-yo most of the time, some days up and some down. We are the Good News Bad News town. Big hotels aren't going to reopen until after the first of the year along with some of our best restaurants, so it becomes very clear that the "return" is taking longer than planned and we haven't located the magic wand that will make it all right. I'm very worried about all the small businesses on Magazine, the shops that make Magazine an adventure and a fun place to spend an afternoon. I'm sure in time all who leave will be

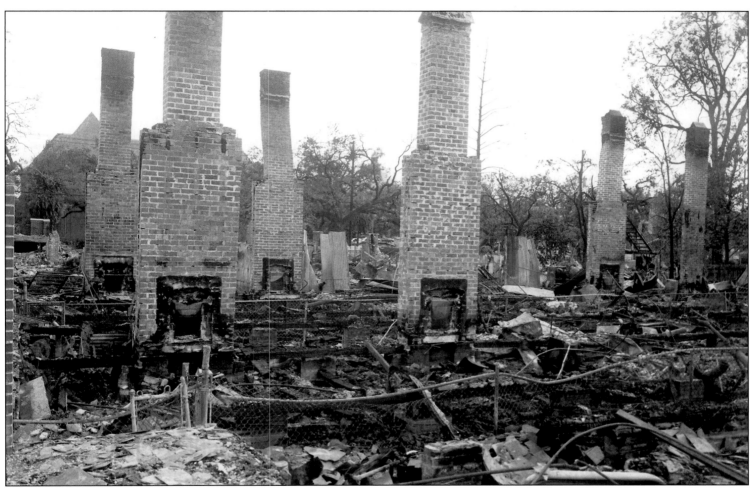

Across from Notre Dame Seminary, a large, old multifamily residence burned
to the ground because high water and low water pressure hindered the
firefighters' response.

replaced. My crystal ball isn't quite powerful enough for me to get a handle on it.

On a very bright side we are still murder free! The trash removal is amazing, out off West End all the trees are taken and there is a chipper that grinds them into chips. Mountains and mountains of trees and branches at one end and at the other big mounds of chips. I'm still trying to find out where all the iceboxes are going? Someone has to remove the freon from each one, now that's got to be a fun job. I don't want to even think about the smell, and flies.

In the coffee shop Still Perkin the conversations are about who had more water, who had more downed trees, more damage, out of this we are finding our badges of merit. Biggest, worst mess, bragging rights. Maybe we should try and find out who traveled to the most locations and/or states during their exile? The best part hanging in the Perkin is hearing the bad jokes and laughs, some things are starting to return to our abnormal life we love and cherish so much. Cathy R. who owns it, lost not one but two houses, one in Lakeview and another on the coast. Yet she is there meeting and greeting her loyal friends and customers. Good for her, lucky for us she realizes how important coffee and friends are.

More later,
David

SUBJ: Thurs. 20.x.05 Day 52

To All:

Stopped by the Laurel St. Bakery, what a little gem, tucked away @ Octavia and Laurel. A quiet street, tables outside, hushed-tone conversation as you don't have to shout above the traffic. Much to my surprise the wait staff was tattoo and body-piercing free. Now that is news in the coffee house world. More good news we are still murder free as best as I can tell. We are breaking new ground for sure.

Well, yesterday our school board started acting poorly again, the infighting and turf protecting is raising its ugly head. Don't these folks get it yet, hundreds of families maybe thousands are sitting on the fence, giving N.O. a chance to show and prove that we are going to do it better and right this time around. Then this . . . I'll bet there are some who say, look at this, it isn't going to change, these fools are incapable of change, we're out of here! This goes for all the levels of government, police, mayor, etc., if they don't put aside their personal agendas and go for the greater good, we're toast.

My shooting has slowed down a good bit, as we are no longer front-page news. I'm still out driving looking, seeing the most unusual images. Lakeview is a ghost town with some green grass trying to pop up. Arabi is still very sci fi. The quiet all over town is amazing. Boarded-up houses still are very evident. Piles of trash appear and then disappear and then reappear. The cleaning and rebuilding process is very much in full swing.

The Sisters are getting their house cleaned and settling in nicely. My block has most of our neighbors back but friends tell me that they are the only one or two families on their blocks. Grocery stores have limited stock, the lingering smell of rot is still there. My project for the day is to find out if my laundry is up and running or will ever open again. I'm running out of starched shirts and if that occurs I might go postal. Could get ugly, me in an unstarched shirt. The hell that Katrina has brought on us!

More later,
David

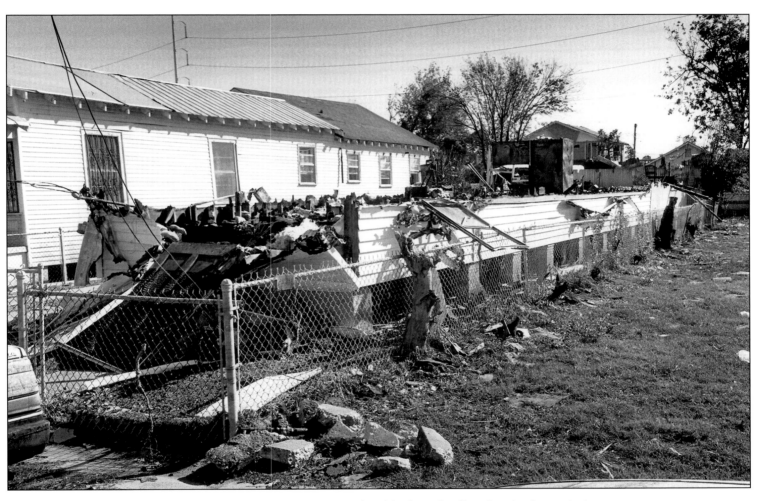

This house burned to the water level before the flooding had receded.

To All:

It appears we are still murder free! This morning on my run I noticed some troops had moved back into the front of the park. Well, at least their vehicles, I'm guessing here but pretty close to fifty. Not sure why but I consider them welcome guests.

From where I sit and stand it seems that our "vices" are coming back fast. Restaurants, bars and cafes seem to be leading the recovery. I guess that makes sense as we "gots to eat" and we love to eat. I am hoping to see more of our "nices" start making a come back. Small businesses, cobblers, dressmakers, clothing stores, whatever. Those little shops we count on so we don't have to go to shopping-mall hell.

The outlook will continue to darken if our city and its Fathers and Mothers can't, won't and don't get along. The Mayor and the Governor can't seem to agree on the day of the week. Greed seems to be the driving force, not only the money but the power and control.

All this reminds me of the dog, bone and his reflection. Wanting both and all and ending up with nothing! One of the many, many examples is the medical community. The patient base has been blown and floated out and away from here. Yet Tulane and LSU still appear to have their blood feud in full. N.O. doesn't need and can't support these two institutions. The duplication of all the services, facilities, staffs never has made good business sense. So unless something amazing happens soon, we will witness these two impressive institutions do a death dance into nothingness. From my position here on the sidelines it saddens me so, that all these smart people are going to let the egos rule their brains. Becoming one and taking on all comers seems to

make sense, instead of staying two and dropping off the map.

One of the Sisters called and said that the woman who cuts their hair was coming to the convent on Tuesday and she wanted to know if I needed a haircut. When she last saw me she thought Sister Mary David needed a haircut.

I must admit, the most frequently asked question is, are the Sisters back and how are they? That is a good thing. So many know the building but didn't know who lives there, so this storm and the article introduced them to N.O. It is one of the many special things that make N.O. our city.

On this first really cool morning, Shelley, Sasha and her folks and I went to the Cafe Du Monde for coffee and beignets. Without a doubt that may be N.O. at its core, its best. Simple, unchanged and outstandingly good.

More later,
David

To All:

A cold front whistled through last night, giving me a 46-degree run with a stiff north wind. The report is that it will be colder tonight. Makes me very happy!

Received some sad news yesterday, an old and dear friend Fred K. passed over the weekend. Fred owned the ColorPix photo lab where I did lots of business, I was there the first week he opened twenty-some years ago and I was there when they shut it down not long ago. Fred's health had been failing and I'm sure the stress of Katrina didn't help either. I was told in Fred style he had just finished a bowl of ice cream and was watching a football game when he left us. He will be missed by me and I'm very sure by many, many others. A very good man and a wonderful friend.

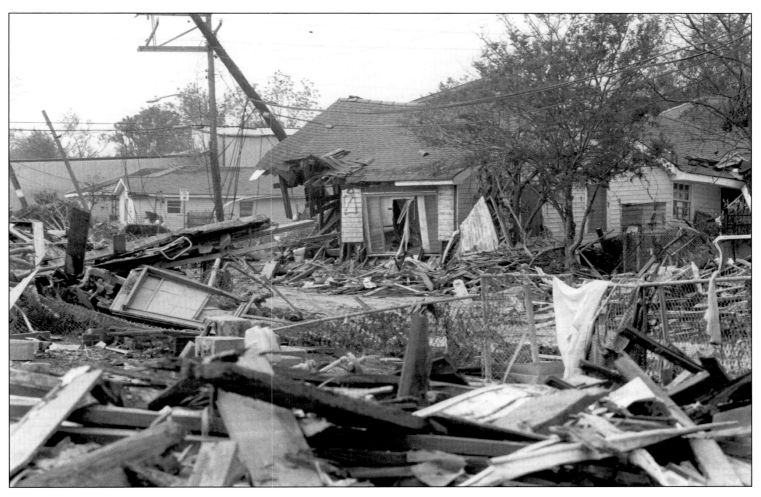

A debris field in the Ninth Ward shows the destructive force of wind and water.

Saturday night, Shelley and I ate at a new place called the Flaming Torch located off Magazine just above Jefferson Ave., a perfect night, cool, clear, we sat outside. Since it isn't on Magazine traffic noise wasn't a problem. The occasional military vehicle gave the meal a WWII feel, only of course if you have a vivid imagination. A limited menu but the meal was very good.

I have had several assignments in which I shoot the interiors of people's homes. I hope most of you don't have to experience this as it is gut wrenching. A home I shot this weekend was at one time a special place, full of wonderful furniture, good art and a collection of items gathered over a lifetime and many many trips to Europe. The baby grand was upside down in the living room, original paintings destroyed by the waters of Katrina. Mold growing from almost everything, a lifetime of work reduced to material for a landfill. Then you go upstairs and it is a different world. Everything in place and neat and just as they left it. The 180-degree view of N.O. as we now know it.

If you ever want to get a feel of how strange our city is, take a night drive along the Uptown area, it is looking good, lots of lights, repairs in full swing. Then pick your street, Louisiana, Napoleon, State, Nashville, Palmer, it doesn't matter, head toward the lake, count the blocks, might be six or eight, not much more than that. It goes dark, maybe some streetlights, nothing on in the houses, the streets are covered in a white dust, this is from the sheetrock ripped out and hauled off. Nothingness, dark, smelly destroyed homes, disrupted lives. After this ride I realized how lucky I was and I really understood what a huge hill we are facing and a task that is going to take years to complete.

More later,
David

SUBJ: Wed. 26.x.05 Day 58

To All:

The weather is still the best news coming out of N.O. It was cool enough for me to have oatmeal for breakfast. Hard to imagine that just a few weeks ago, with no power, peanut butter and water, sweating 24/7. The cooler weather has to be helping slow the growth of the mold. It's a shame one of our chefs can't figure out how to cook with the stuff, as there seems to be an endless supply. It is also amazing that Wilma blew through and the news from Florida is that they are already on the mend. Guess when the water comes in and goes out, not like us where the water came in and decided to stay.

Weird images keep finding me, and my grassroots network of friends are keeping me informed about possible images. I'm trying to get down to the mouth of the river as I understand there are lots of odd images.

I've heard about someone who escaped to Lake Charles, major home damage, lost his job, said he wasn't coming back, moved the remaining furniture over to Lake Charles. Well, the draw of N.O. was just too great, he has reloaded the rent truck and is hauling all his stuff back here. Now is it the draw of N.O. or was it staying with his mother-in-law, no offense mother-in-laws, just a bad joke!

I'm less than impressed with the committees that the governor and mayor have picked to guide the city and state. Let me explain, good folks all, but it is the same old crowd. Where is the new blood, young Turks, those who are going to be here for the next thirty years? The vast majority of these people have made it, nothing to prove. Sure, a handful would be great on the committee, offering guidance, historical view, etc. I think we need ones who are raising young children, who are fighting for the schools, quality of life issues that have slipped away from us over the last quarter of

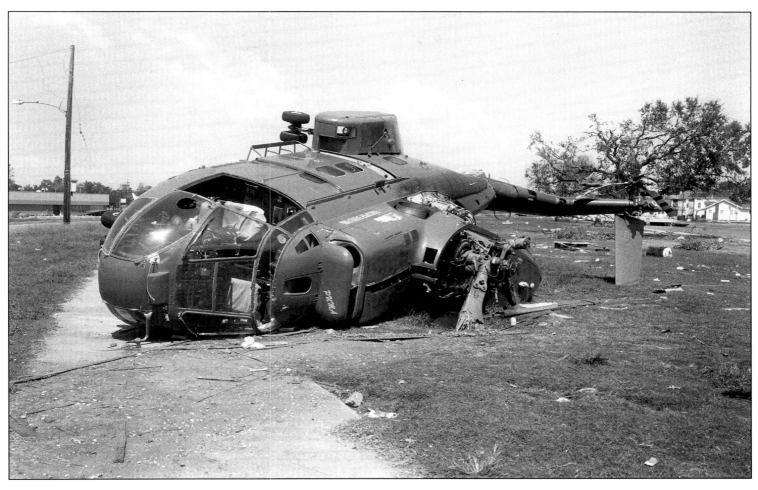

A downed rescue helicopter on the banks of Bayou St. John
was subsequently cannibalized by looters.

a century. We know how these people will react on almost every issue, it is just more of the same.

Albert Einstein said, "We cannot solve problems by using the same kind of thinking we used when we created them." Well, guess what, most of these folks are offering the same kind of thinking.

More later,
David

To All:

It must be the weather, as in my world things are looking up. This morning as I'm starting my run, low and behold in the middle of the street is a nice-looking bike, one of those street/off-the-road jobs. Looking around for an injured rider or whoever, I stand around in the dark pondering what to do. So after much thought I left it leaning up against the telephone pole figuring the owner might be back shortly. If it was still there I would take it to my house for safekeeping. There it was on my return, in the early daylight it looked like a nice ride, so now it sits at my place for safekeeping. Wondering was it stolen, did it fall off someone's truck, who knows. Maybe I'll have a new toy to play with. I looked and it isn't from FEMA.

I'm also intrigued by all the out-of-town workers here. I've been talking with some and asking about how and why they made their way "Down Yonder." Guys from Oregon, Michigan, you name it and they are here. Plus all the folks from Central America. Most of these guys are just that, guys with skills and tools. Loaded the truck up and drove across America to this hellhole, nothing in writing just their dream to make some money. Sleeping in the truck or on the ground, eating beans from a can or MRE's if they were lucky, seven days on, just work, work and more work. Trying for a piece of the pie! So many of the workers from Central America are former Florida hurricane workers. After Katrina hit, they gathered up their stuff and headed here. Doing the rough, dirty work, living together eight to ten in a room, cooking beans and rice on little camp ovens. Trying to get a foothold in the U.S. Probably just as many of our great, great-grandparents did. So far and as a whole I'm impressed with their drive and willingness to take a big chance coming here with not much more than their desire to work.

I've been trying to photograph them after learning their stories but most decline as they really feel unwelcome here. Their response has been, they're here willing to work, just lucky so far and plus there is more than enough work to go around. Some have told me they tried to hire locals to help but most aren't willing to work the long hours and the seven days it takes to get the job done.

Again, in my mind's eye, the rebuilding of N.O. is taking on a WPA-type feel, not that I was around, mind you. Also with all these transient workers there could be a little "Dust Bowl" feel as well. Workers' camps, trailers, living on the cheap! Guess this will be something we will tell our grand-kids!

More later,
David

To All:

Halloween is here so the end of the hurricane season is a month away. Guess Beta will set a record, who knows what the last month will bring. As we wait for the end of this hurricane season, our little part of the world will forever be changed.

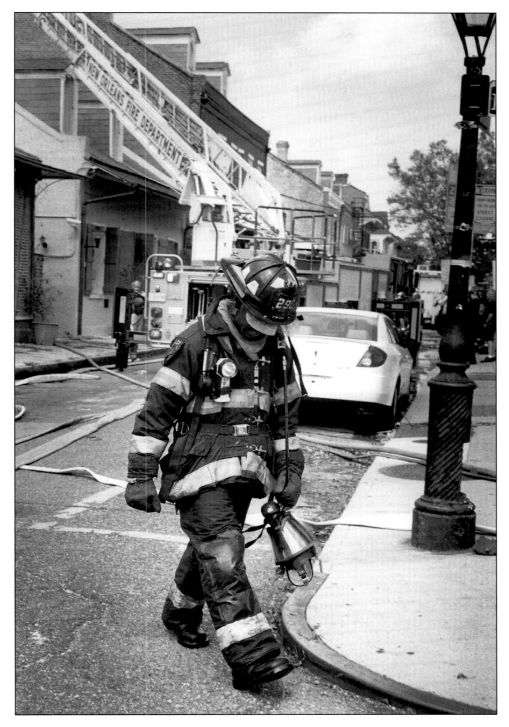

Exhausted and extremely hot firefighters from around the country tried to help with this French Quarter fire. Several blazes broke out when the power was first restored.

More of us are coming home but there seems to be a real slowdown in little businesses opening back up. More and more stories of those who are going to stay and those who are going to leave. No real pattern has developed. I've heard our little strip of land here that didn't flood described as a Caribbean island, one mile wide and seven miles long, can't remember which island fits that description. Hope we realize that this little island needs the rest of N.O. as we don't have all the services and people we need to carve out a life. Each day seems to bring pluses and minuses about our future.

I'm off to B.R. to shoot the Saints game, that should be interesting! Can't wait to hear the reaction to the team. An interesting survey would be who is most disliked in Louisiana, Bush, Nagin, Blanco or my vote, Benson. Anyway, maybe the team will feel the magic of Tiger Stadium and surprise us all.

I'm headed to Boston for a few days, will be interested in how they perceive our situation and try and gauge their interest and concern for us poor crackers down yonder. Will be shooting two assignments up there, hope to see some autumn colors and I plan to eat my weight in lobsters, hope they are still in season.

The sisters report things are slowly returning to normal. Still no masses being said over there as the priests aren't back at Loyola just yet. The gift shop is open and people have been stopping by and getting some gifts, cards, Sister Mary's pralines and the other goodies.

More later,
David

P.S. Back from the game, well I'm not sure I'd call it a game, the Saints don't ever seem to show up and play. What a wonderful afternoon to sit in a stadium, reminds me of my early years here when the Saints were up at the Sugar Bowl. Parked the car and walked across the campus to the game. Wooden bleachers, hot dogs and beer, real football food. Nachos are you kidding, popcorn, beer and dogs and we were still losers, but it was fun sitting in the sun on an autumn afternoon.

The only excitement was up in my client's box, the Mayor and Governor were both there at the same time. The air was alive with excitement, I am happy to report, I've got a picture of the two of them cheek to cheek. I will also say both are very nice, gracious and well-intentioned people. Both in my estimation are ill-equipped for the task and job that lies ahead of them. Truly a sad situation.

I left before the game was over and I haven't checked to see or hear the outcome, so who knows, they may have surprised me with a win?

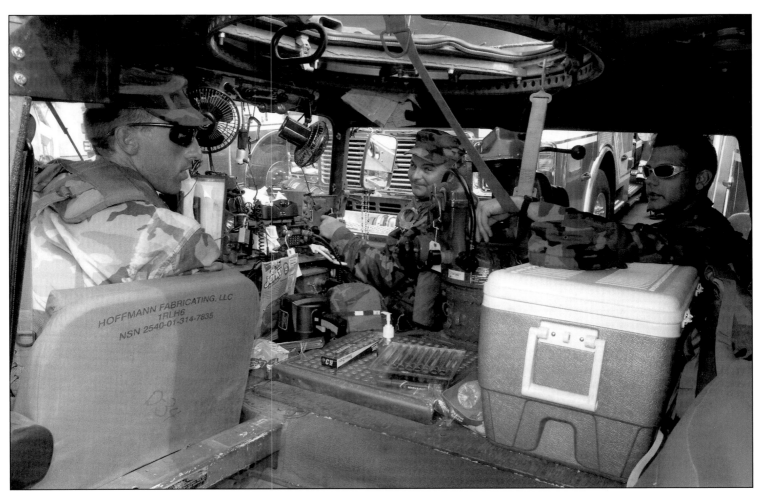

Just back from Iraq, now in New Orleans, these Guardsmen mount
their Humvee, readying for a day in Uptown.

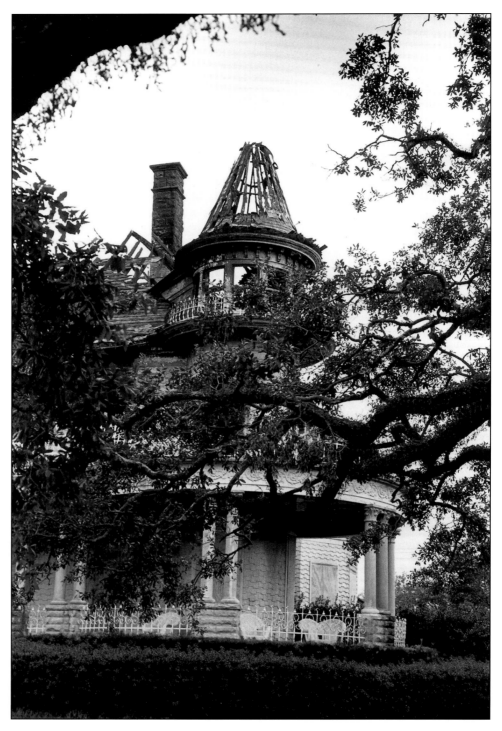

This Audubon Place home was another victim of fire.

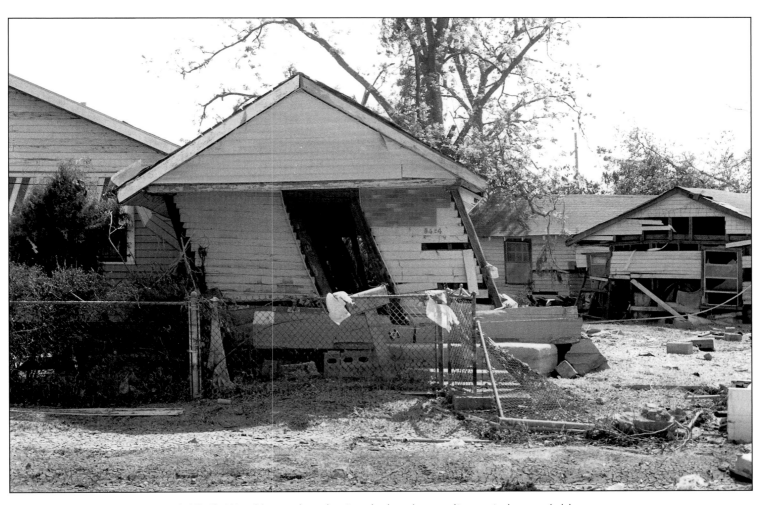

A Ninth Ward home barely stands, leaning on its next-door neighbor.

III

Inside Looking Out

Driving was still a challenge as street signs were gone, landmarks burned. I would get confused trying to find an old familiar place. Intersections were dangerous because no one seemed to understand the protocol of an unmarked corner. There still weren't any stores open, and gas and water were of major concern. The reports of crime were constant, and I felt very unsafe in the place that had been my home all of my adult life.

As a photographer, I was feeling overwhelmed because I couldn't begin to tell the story. It was too big for anyone to understand, much less photograph. I was shooting lots of images, but there were so many I missed. I couldn't be in all the places I wanted to be. The days were too short, so much of my time spent gathering information and trying to get gas and food.

On North Broad Street, the high-water mark adds new meaning
to a church's stated mission.

To All:

Remember autumn? Changing colors, falling leaves, burnt oranges, deep reds, raging yellows, that's what I've been seeing. No rotting garbage, no Entergy trucks resetting poles and stretching wires. Large groups of children out on Halloween gathering and collecting goodies. In Duxbury where I was, my run was on country lanes with the Atlantic Ocean within sight. Fallen leaves on the road, the crunch under my shoes, a cool breeze. For me exciting, for the locals a warning of the impending winter that is just around the corner.

It is amazing to me how fast we the Katrina victims have dropped off the radar screen and how all our political infighting has hurt us in the eyes of our fellow Americans. From where I'm standing here, it seems most feel that certain areas of the city shouldn't be rebuilt. Something that I agree with. An extremely difficult decision for sure but eminent domain should be used and those in the 9th and other areas there should be given fair market value and told their area isn't going to be rebuilt. The levees can't protect it and there isn't enough money to spend and upgrade them. Now will that happen? I'm not holding my breath, we don't seem to have a leader or leaders willing to make that kind of plan, the will isn't there. So once again we will lower the bar and continue on our path of failed history. Knowing that this will repeat itself someday down the road.

As I talk with folks up here and try to share with them some of the experiences that I have had, I realize that the English language fails in conveying the size and scope of Katrina. The people up here can't grasp the size and scale of the damage. They don't understand why so many people didn't leave when told. As I try to explain and give some background history their eyes glaze over and they lose interest as

there isn't a quick fix and they know that we will be dealing and struggling with this for years to come.

When asked what I find most disappointing, I respond all the finger pointing, backbiting and dancing around the tough subjects! I'm concerned we won't make the hard decisions and set a new course for a better N.O. I also wonder when is the majority going to stop pretending to be the minority and start taking responsibility for their actions!

More later,
David

To All:

Sorry for being so long getting back to you. Traveling to and from N.O. is a real adventure. It has been difficult for the past several years as you can't get many direct flights from here but it has been really compounded by Katrina. The long-term parking lots are almost empty, short staffed on bus drivers. The airport is a ghost town, most of the shops are closed, couldn't get any coffee. The number of flights are few and far between. Upon my return N.O. is now the blue roof capital of the US. On final approach the city is dotted with them, places where I wasn't aware of the damage. My car was covered with dust, as I learned later one of the dump sites is near the airport. There is a fine layer of dirt over most everything. Driving back Uptown, the Earhart Expressway is sad, all the billboards are windtorn, more blue roofs, trailers popping up in the front yards of damaged houses. The recovery process is so slow I'm wondering if some of these trailers will become a permanent fixture in some neighborhoods.

As you would and could imagine, the questions and reactions about Katrina are and were all over the place. People want to know why we the city and state weren't more pre-

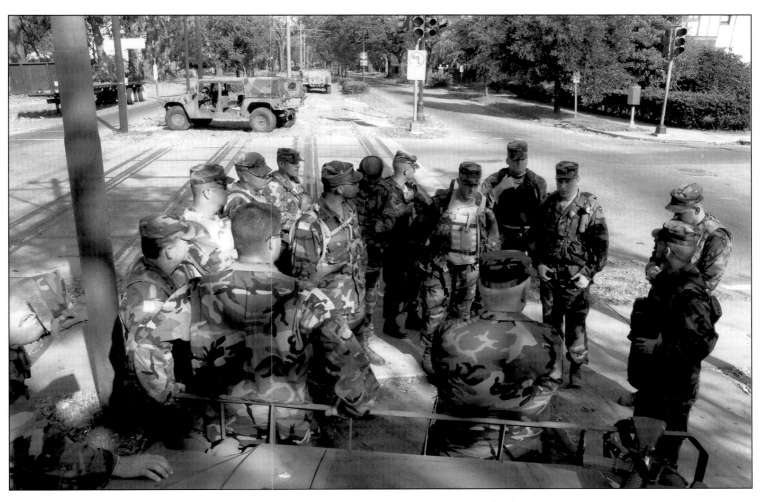

A National Guard squad receives its orders on St. Charles Avenue.

pared, I wasn't able to answer, or shed any light on the subject, but with all the questions asked of us, one has to wonder. Then of course the Feds weren't fast enough and they never knew just how poor we are. I think some expected me to be barefoot and in tattered clothes. In this instant-information world it's amazing how much misinformation is out there.

Was pleased to see Audubon Golf was up and running, nothing does the heart good like seeing some overweight guys in really bad-looking shorts playing a round. Magazine Street was packed with shoppers, a band was playing just above Jefferson, CC's was swinging. So our little island of civilization is beginning to perk. The neutral grounds and corners are jammed full of open signs and mold removal offers, psychic counseling. The sign makers are probably going to be our next millionaires. I have also been amazed at how many truly ugly sofas have lined the curbs. What were we thinking when we bought those awful things, one wonders who created them and then convinced us to buy them? Free enterprise at its worst!

Glad to be back, but sad at the constant reminder of just how long this recovery is going to be. If you're not ready for the long haul, better move on!

More later,
David

SUBJ: Wed. 9.XI.05 Day 72

To All:
Still murder free, violent crime is way down. Then I see this story in the TP, we were number one in the country with syphilis and number two in gonorrhea last year. Hope those numbers drop like the others or we're not out of the woods just yet. Curious, wonder if any of the bars are running pools on what will come first, a Saints' victory or a murder? Hmm, wonder what the Vegas odds would be on that?

Most around town seem to be suffering from a Katrina cough. Sheetrock dust and no rain and all the other stuff floating around is making our lungs and eyes very unhappy. On two different occasions I've had to have my car's tires checked for nails. The first time they removed eight, the second time just five. Wherever I stop I'm finding roof nails in the streets. Another joy of the Katrina adventure.

The little island we call Katrinaville seems to be settling in to somewhat of a normal existence. The return rate is slowing, lots of housework is taking place, tree, icebox removal and street work seem to be progressing. I've been revisiting different areas and there is lots of progress to report, most of which is just the removal stage. Some rebuilding but not much. The areas where the trees and limbs are being put are amazing, thirty or forty feet high, blocks long. Trucks bringing more all day long, machines grinding them up into chips. City Park is the center dispatch area for all the trucks, hundreds and hundreds of them lining up there each day. Campsites, tents and trailers dot the area, workers from all over using City Park as their staging area to work on the cleanup.

More later,
David

SUBJ: Fri. 11.XI.05 Day 74

To All:
"Times are not good here. The city is crumbling into ashes. It has been buried under a lava flood of taxes and frauds and maladministrations so that it has become only a study for archaeologists. Its condition is so bad that when I write about it, as I intend to do soon, nobody will believe I

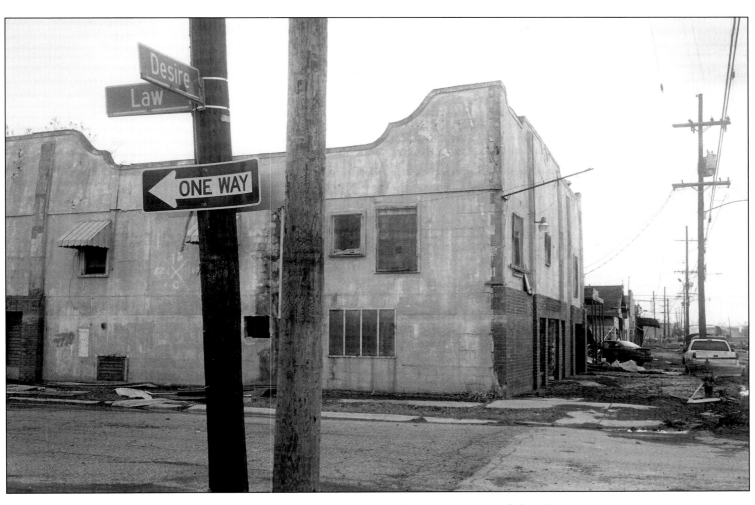

Street signs at an intersection in the eastern part of the city
express forces at cross purposes?

am telling the truth. But it is better to live here in sackcloth and ashes, than to own the whole state of Ohio."

Those my friends are the words of Lafcadio Hearn, who moved to New Orleans in the 1870s, writing to a friend back in Cincinnati. Guess things haven't changed much, just the looters wanting to wear designer togs as opposed to sackcloth.

Stories of overpriced work seem to be the norm, it appears that the quote you get is inflated but the contractor will do the work for whatever the insurance will pay. I can't figure out what is the going rate for anything. Maybe it's me but I think prices in general are being raised across the board. One of my favorite joints, Taqueria Corona, has jacked their prices, the chicken taco salad with a beer was less than $10, forget it, now just the salad has gone up a couple of bucks. Gas in Orleans remains high with very few stations open.

Not sure what is going on but I'm seeing more military patrols around town. There also seem to be more guards attached to work crews. One has to wonder if these crews are helping themselves to things that are left unattended? Several folks have mentioned that their houses in Lakeview have been entered by someone other then themselves. Are we getting lazy and letting our guard down and the criminals are seeing crimes of opportunity?

I also heard the N.O. small business community, which was over 100,000 strong, may lose as many as 90,000 businesses by the end of the year. If that bit of information comes true we will really be a shadow of ourselves. Hope my little biz, this one-man band, makes it.

The storm was the event, the story is the rebuilding of N.O. and we haven't finished the first chapter!

More later,
David

To All:

Nice weekend here, cool on Saturday and we got some much-needed rain on Sunday. Plus it was the bye week for the Saints, so no grousing about the poor play and trash talk about Mr. BringNewOrleansBackBenson.

Spent a good bit of Sunday roaming and shooting in the Mid City area. What a mixed bag of recovery. Lots of damaged houses, many that have fallen down, others with people living in them and they appear to be without power. Still others with FEMA trailers out in front. Boats, overturned cars, garbage and that never-to-be-forgotten smell of rotting food. As I drove up and back and around the blocks, I was reminded again and again how total the destruction was and is. At one of the standing houses, there were the marks of the searches, notes of how many animals were found, also there was a list of names, I'm guessing of those who lived there and next to the names were phone numbers with different area codes. Informing whoever came by where the former residents could be reached. Interesting and clever, I think.

As I travel around and revisit the city neighborhoods, the images change yet they are the same. Drying out, trash removed, but then you can really see the destruction and dismay. Open front doors, busted windows, furniture gone, shells of what once was a home. A broken city to be sure, one without much spirit left. The mood and tenor is quiet, I'm sure most are still in disbelief, wondering how and when this nightmare will end.

Unfortunately our paper the TP and its publisher are not willing to cut loose and dig, no holds barred, and tell us the real truth. I would hire two dozen investigative reporters, outsiders, give them one order, DIG, don't leave a stone unturned. The NYTimes, Chicago Trib, LATimes and many others would be racing to expose the mistakes and blunders.

As residents return to a city still without power, advertisement signs proliferate.

It is my opinion that won't happen. I know the City Hall has a huge manual for and about Mardi Gras, how to prepare, who does what, when and where things must happen and take place. From what I've seen and heard we don't have anything like that for hurricanes. Hotels and companies do, why doesn't and didn't the City of NO have such a book. Why with a police dept. known for its expertise in crowd control, Mardi Gras, Jazz Fest, Sugar Bowl wasn't there a plan for the Superdome and convention center? These are questions and problems that need to be answered and in our society, newspapers are the vehicles that act as the checks and balances. We need a newspaper that will and is willing to do just that. Not softball stories and clichéd answers!

Just ran into Judge Hansen, son of the Hansens who gave us Hansen's Sno Bliz on Tchoupitoulas. He told me his mother passed away after the storm. Evacuated from Touro, reunited with her husband and then she passed. Along with Joe C., legions of N.O. have left us because of Katrina, brokenhearted, overwhelmed, we have lost some of those who made this place so very different and special.

More later,
David

SUBJ: Tues. 15.XI.05 Day 78

To All:

I've been racking my mind as to clever drinks that could and should be named after the storm and the aftermath. A Katrina, looter, levee break, the list is endless. I'm just not smart or clever enough to come up with the booze and combinations to make them good and funny. I have come up with a title for a song, hoping one of my musician friends will write the lyrics. "Sheetrock Booger Blues." Off-color and poor taste sure but after a while my mind wanders off

the straight and narrow. Humor helps me deal with sadness, of course most of you will remind me that my title isn't funny.

An almost full moon led me around the park this morning for my run. Longing for the moons of Katrina, with no ambient light to diminish their beauty, no noise to distract from their job of directing me on my run. There are many things I miss about those strange and unreal times after the storm.

More later,
David

SUBJ: Fri. 18.XI.05 Day 81

To All:

Cool, clear weather has descended on Katrinaville, feels like autumn and Thanksgiving! Hope this weather lifts the spirits of most, it sure does wonders for mine.

Ate with the Sisters yesterday, well, it was the noon meal but they call it dinner. The monastery is filled with Thanksgiving decorations. Everyone in good spirits, over a wonderful meal they shared stories of neighbors and those who had read about their adventures. I told them more of my stories and how I maneuvered around N.O. under the threat of forced evacuation. How I managed to have enough gas, water and peanut butter. Washing sheets by hand and managing to stay out of trouble. It was a small Thanksgiving dinner for me, Sister Mary David, and the nuns.

Was up in Monroe earlier in the week and drove through Jackson, still seeing lots of reminders of Katrina all the way. Amazing how large an area this hurricane had an impact on. Driving back into N.O. the traffic leaving the city was huge. Football-like traffic out of the city. Then as you continue into the city the dark areas are so evident from the interstate. My,

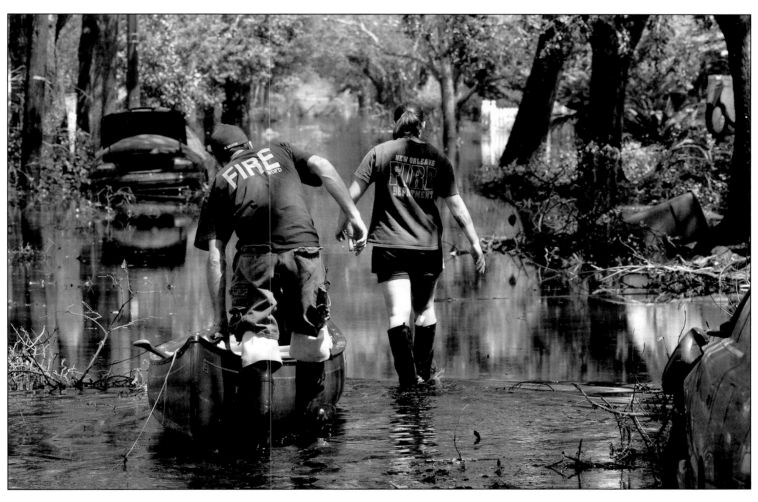

On Octavia Street, in Uptown, residents salvage whatever they can.

my, we aren't out of the woods yet. Almost three months have passed and they are still finding bodies and there are areas that aren't opened up yet.

A friend from Chalmette shared her story with me how her house was covered with water, also mixed in with the water was oil from Murphy. Total destruction of their family home, nothing to salvage but memories. She also told me that most of her neighbors, friends and family down there are not really interested in rebuilding. Scared, overwhelmed and upset and unsure of the future and the next storm. Living in Baton Rouge, driving to work each day in N.O. All the uncertainty is wearing heavy on all in her family. I am hoping to go down with her to her old "hood" and have her give me a tour of what was once her life.

Here are a couple of the many ideas for drinks that I'm receiving from my whacked-out friends. "Looters-shooters," another "Levee Break—two shots hold the water." Help I need more.

Also I'm hearing lots of Katrina speak, one of the best so far was someone complaining on the radio that their insurance adjuster was "AOL," the announcer asked again and it was repeated the adjuster was "AOL," hadn't been back to see the insured and finish the report. Got to love Katrina speak.

More later,
David

SUBJ: Mon. 21.XI.05 Day 84

To All:

The quality of my life took a huge leap on Saturday. My laundry reopened and I am back in business with starched shirts. I had managed to make it through without going to another laundry. Life is good and who cares I still don't have cable. One lesson learned from Miss Katrina, we take our victories in small steps, sometimes very small steps.

The other bright spot for this weekend is our hometown boys, the Mannings, are doing us proud. Class, style and great gamesmanship. A sportswriter's dream would be those two facing each other in the Superbowl here in N.O. The press would be staggering. What would Olivia and Archie do? I guess sit on one side each half, trying to contain themselves. Amazing and cool having not one but two boys being great for themselves and their folks and us football-deprived fans of N.O.

Traveled back down to the 9th Ward and other areas, snail's pace for sure. Not a clear plan for recovery. Did see and hear stories of the fishermen, who although were hard hit are out fishing. I guess crabs are running big and strong along with shrimp. Their docks are destroyed but it's plain and simple if they don't fish they don't eat. I guess the fruit crop is supposed to be a good one. On that I'm going to be at the Uptown Green Market at Uptown Square tomorrow, Tuesday, and support those hale and hearty folks who are making something happen.

This week being Thanksgiving and all, I'm going to be shooting the soldiers on duty. Away from home eating MRE's, tough duty. Hoping to be able to smell turkeys roasting, as in the past, on Thursday morning as I run through the park. I must say I find comfort seeing the military vehicles on patrol. Four soldiers riding, moving slow through the "hoods" is a good deterrent. When NOPD rolls, windows are up and they are moving much faster, sitting low giving me the impression they are trying to avoid any and everything, putting in their hours. Plus I really don't think the thugs are very scared of the cops, soldiers are a different story. Our

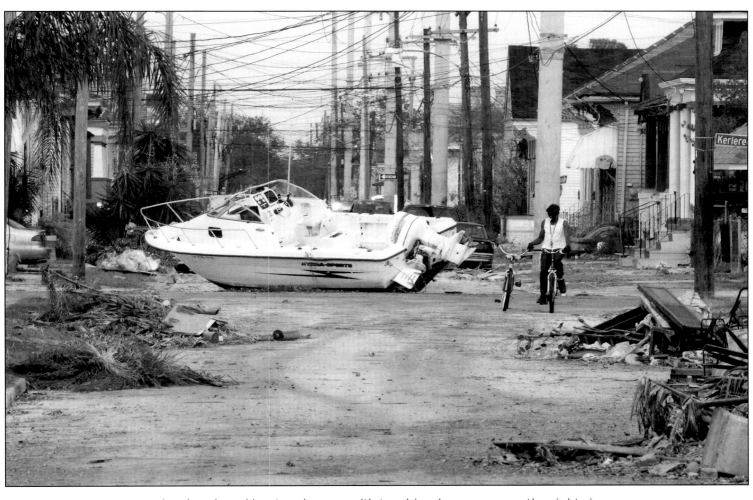

An abandoned boat and a man with two bicycles are among the sights in
Broadmoor, one of the most damaged areas.

murder-free world has ended, last count was two murders. Sorry to see that streak end.

More later,
David

SUBJ: Wed. 23.XI.05 Day 86

To All:

My favorite holiday is on us. It's not about gifts, it is about family and friends and eating, which we seem to be getting better at every day. So enjoy and most of all travel safe.

Wow, in eighty years N.O. will be gone according to 60 Minutes. So if the big quake hits Calif and the other LA drops off into the Pacific and we become part of the Gulf this country is going to be a lot easier in geography class.

We seem to be entering a period of very slow progress, lots of demolition is done, not much rebuilding in the neighborhoods yet. Reports on the hotels are sad, some of the big ones won't reopen until well into 2006. The report of LSU Med considering moving to BR cuz the Feds won't lay 700 million on them for a new Charity. You've got to love these poker games different groups are playing. I wish the TP would dig into their files and share with us the post-Betsy stories. I don't believe FEMA was around, I don't think the displaced were housed in hotels and yet we rebuilt. I know, I know things are different and Katrina is worse and there are more people but I'm seeing lots of people sitting on their hands waiting for the Gov to fix it. I hope they don't hold their breath as I think thousands will suffocate. So here we sit, stuck in the middle, I'm seeing lots of anger and frustration, businesses have work but no workers, people willing to work but no place to stay. More stories each day of business as usual.

The images still amaze me, mountains of trash, tons of garbage, trucks and trucks of sofas, blue roofs. Long lines at the businesses that are up and running, long waits for tables at restaurants, limited menus, shortened hours. People still finding friends, hugs and kisses, sharing stories and knowing they are safe. Bought a cup of "joe" for an Air National Guard the other day, only to find out later the coffee shop gives it to the soldiers for free. He shared with us in line the amazing attempts of looting he has seen. Large rent trucks pulled up to houses where the owners have stored their saved belongings on the second floor, clipboard in hand, looking very official so the neighbors don't get suspicious. Everything pulled out and gone, amazing nerve. Some have even tried to convince the police that it is their house, so this soldier tells me they are challenging all. As he said, it is hard to believe how the crooks are trying to rip off those who have been hit the hardest.

Eat well and lift a glass to our fair city and its future!

More later,
David

SUBJ: Sat. 26.XI.05 Day 89

To All:

Overfed, overdrank and overate, managed to stay away from the shopping centers, yes another great Thanksgiving!

On Thursday I was out early looking for images, hoping to find Nat Guard eating their turkey MRE's, no luck. Then hoping to locate a Red Cross kitchen and showing them feeding those who are working their way back. I guess I was out too early. I did find something quite strange, two houses that were burned but only about two-thirds of the

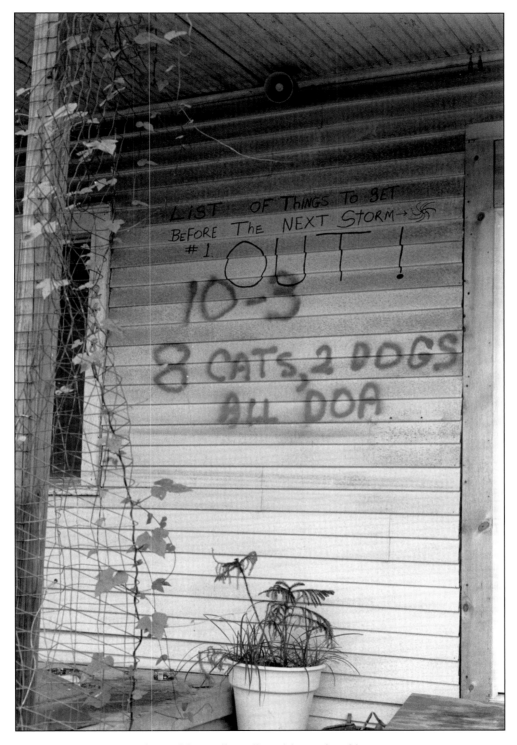

The writing tells a disturbing tale of loss.

way down. Then it dawned on me what I was looking at, these were houses in a flooded area that caught fire, burned to the waterline. Wow, what a strange and unreal look about these two places, brick pilings and floors and about two feet of walls all intact but nothing else left, roof, walls, windows all gone. Next to one of the places was a boat, it also burned and melted to the waterline. Then I found and looked into some small very modest places, everything upside down, just abandoned, pants and shirts still hanging in the closets, someone's home, someone's life, left there wide open with no indication that anyone had been back to check on or start rebuilding. Words and pictures really don't express the sadness that all these hundreds and hundreds of homes convey.

When I awoke this morning, I was confused what time of year it was. Of course remembering Thanksgiving but still not really believing it was the end of November. Someone else said it best, it feels like our lives have been and were on "pause" for Sept and Oct, time was lost or sort of covered with disbelief and questions. We continue to dig out from under the spell of Katrina.

More later,
David

SUBJ: Mon. 28.XI.05 Day 91

To All:

By my count, we have passed the three-month mark. Seems like just yesterday and it even looks almost that way as several parts of the city haven't made much progress. Driving home last night after going to a movie, using the Earhart Expressway, coming over the last raised part before entering Orleans, there before me was darkness. Sure the streetlights are coming back on but hundreds of houses there still in the dark. Very little traffic, weirdness abounds, neighborhoods where front porches used to be full of sitters, talking, laughing and spending evening time with friends and families now sit empty. Alone, but the mess of flooded cars, trucks, sofas, iceboxes and all the rest there piled high waiting to be hauled away. Maybe one house every two blocks had power. Wonder how they feel, it was strange driving through, what must it be like being the only one back in your block. Knowing that most of the houses aren't going to be back very soon as the damage was far greater at theirs than yours. Wondering when evenings will once again be spent sitting on the porch talking, laughing and sharing life.

I really wish the TP or some other media group would do a serious series, neighborhood by neighborhood, blow by blow of who and what has been lost. Sharing with us the tax and income information, number of houses, demographics, age, race and all the rest, so we can see who and what makes up this place we call home. Helping us understand the loss of revenue and its impact on City Government. At the present we all are just guessing who and what makes up N.O., show us how it all breaks out and how it all fits together. At present each and every council person would have us believe that their district is the most important and without it N.O. will and would drop off into the Gulf with or without a levee system. Smoke and mirrors aren't the tools of rebuilding, real facts will let us make better decisions, hard ones too, but at least we will be dealing with facts instead of political speak.

Still feeling the effects of a nice Thanksgiving, how is it eating is so darn easy. Now begins the serious eating season and then this year will be over. Such a blur.

More later,
David

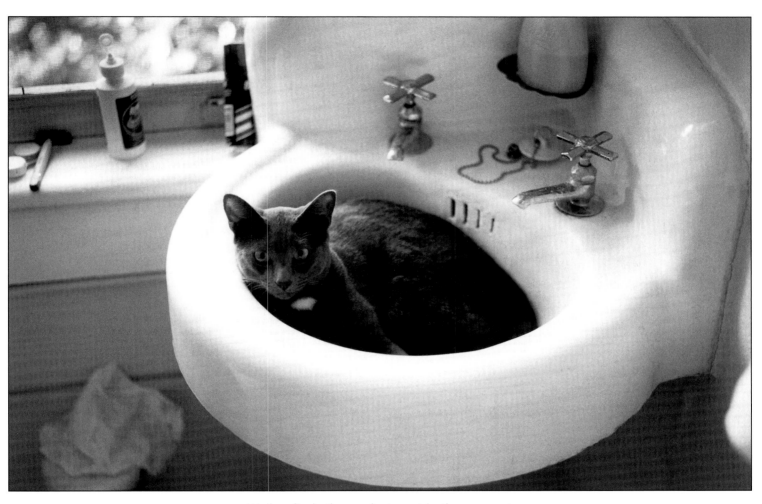

Walker finds the coolest spot in the convent.

To All:

At last the hurricane season has come to an end, a year for the books I'm sure. Sights and sounds still abound. I keep saying that the storm was the event but the story is the re-build or lack thereof. It is widely reported that over 200,000 homes were lost and there only appear to be about 60,000 back in N.O., only about 27% of the restaurants are open, so where does "getting back to normal" fit?

I get e-mails every day with angry letters and notes wonderfully written. Sharing the writers' frustration about everything, the slow pace of recovery, the way the media reports on and about us, bad and stupid decisions being made all around us. I enjoy and marvel at these notes and how well written and passionate they are. These people should be di-recting their efforts at the powers that be. They should redi-rect their energy and talent to their church groups, schools, neighborhood associations, grab our leaders by the neck and let them know loud and clear we aren't going to allow it to be business as usual. This brilliant writing zooming around the Internet is part of the problem, I'm sure they feel better after writing it but nothing is getting done. This enterprise N.O. is ours, we are the shareholders. Teachers, postmen, police, politicians, firefighters, street cleaners all work for us and if we aren't happy with the results, now is the time to let them know and change it. Raise the bar, school's out, we can cre-ate a new set of rules. Let's not just talk amongst our e-mail selves.

I seem to be sleeping more with this cooler weather, it wasn't all that long ago that I wasn't able to sleep because of the sweat sliding down my face, waking every hour or so because of the heat. The cooler weather poses problems for those without heat, I'm worried that little Coleman-type heaters are going be used for heating and eating and we will see an increase in house fires. As the weather changes so do the dangers for this recovering city.

As I'm out shooting, I'm seeing lots of old folks sitting on the porches of their dark and powerless homes, I'm wonder-ing if they stayed. Most of them weren't flooded but many suffered lots of wind damage and I'm sure water damage from the rains. Sitting quietly on their porches, looking and watching, I'm going to start talking with them and find out their stories. I'm also seeing lots of young men standing on street corners, not working, or so it appears. Trying to be politically correct here. These guys appear to me to be the bad element that we were hoping wouldn't be coming back. I hope I'm wrong but sometimes you can judge a book by its cover. Very bothersome.

More later,
David

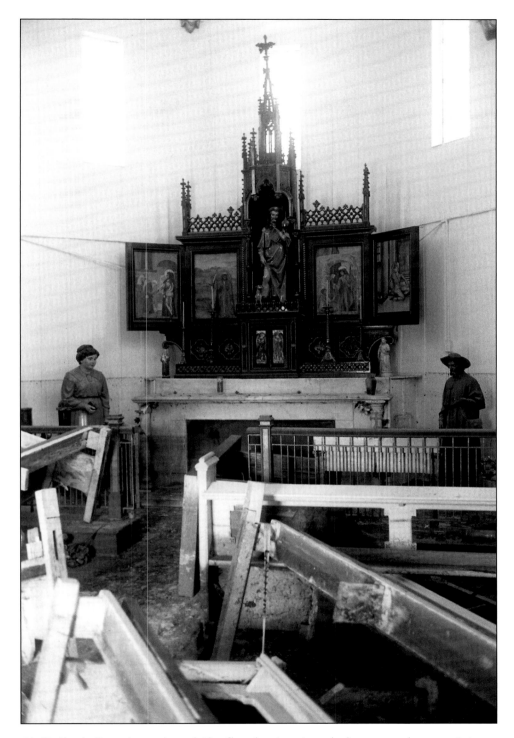

At St. Roch Cemetery chapel, the floodwaters toppled pews and some statues.

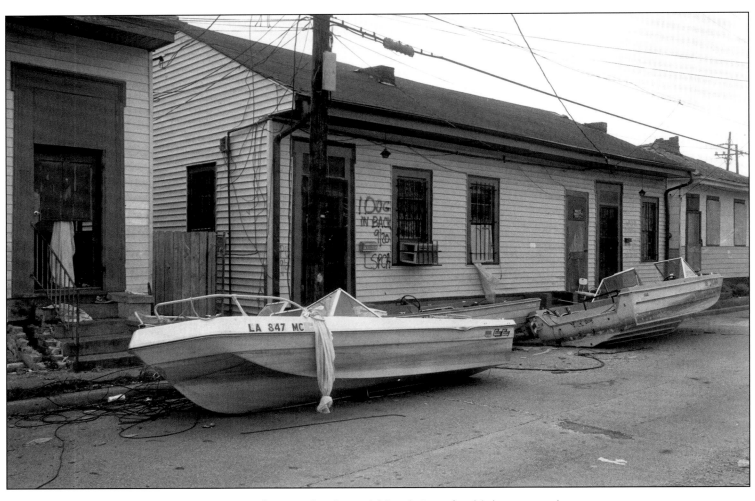

Boats used to get family and friends to safer, higher ground
are left at a curbside in Central City.

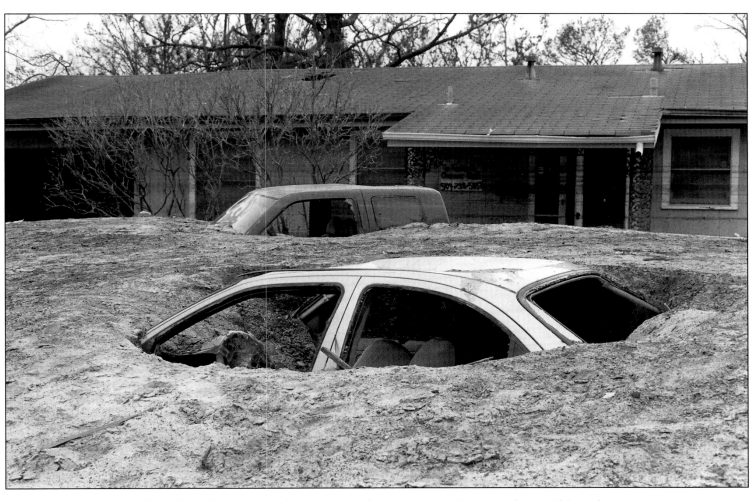

Sand from the London Avenue Canal breach covered cars and everything else
in its path. The owners of the house escaped the fast-rising water by chopping
through the roof.

The marking indicates one dead body was discovered September 12.

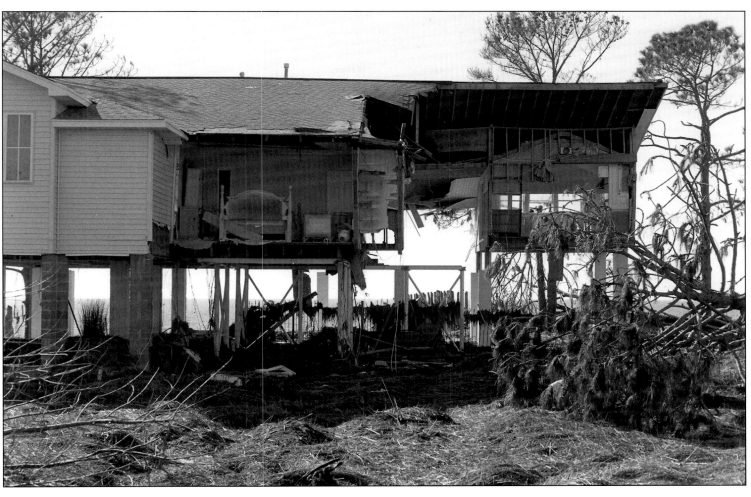

The exposed back of a house on the lake in Slidell displays
a bedroom and its furnishings.

Kenner resident Angela M. collected and cleaned hundreds of abandoned
refrigerators and shipped them to her native country of Honduras.

I wrote my e-mails at this desk in the convent and then
transmitted them from my gallery at The Rink.

Downed trees from all over the city provided a steady diet
for the grinding and chipping machines located in a field near the lake.

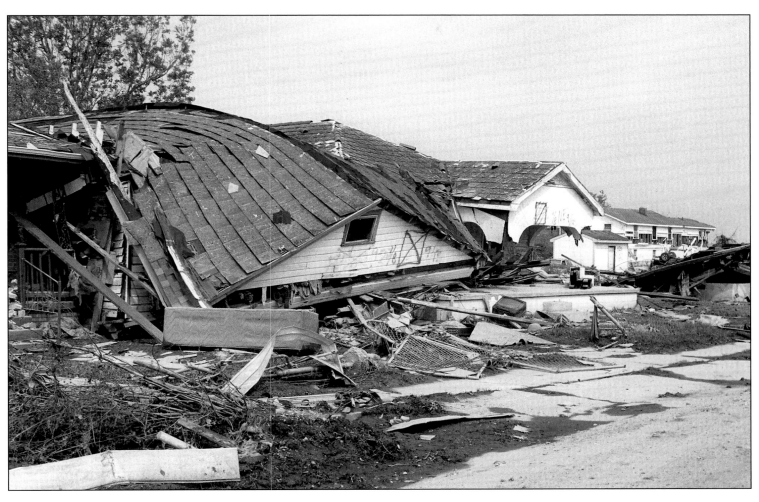

A house is brought to its knees in the twice-flooded Lower Ninth Ward.

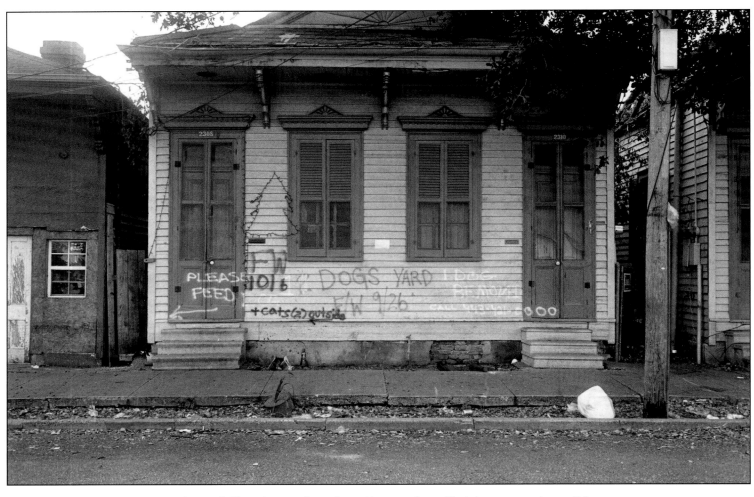

In Central City, decorations from the previous Christmas remain on this
residence alongside updates about the well-being of the animal occupants.

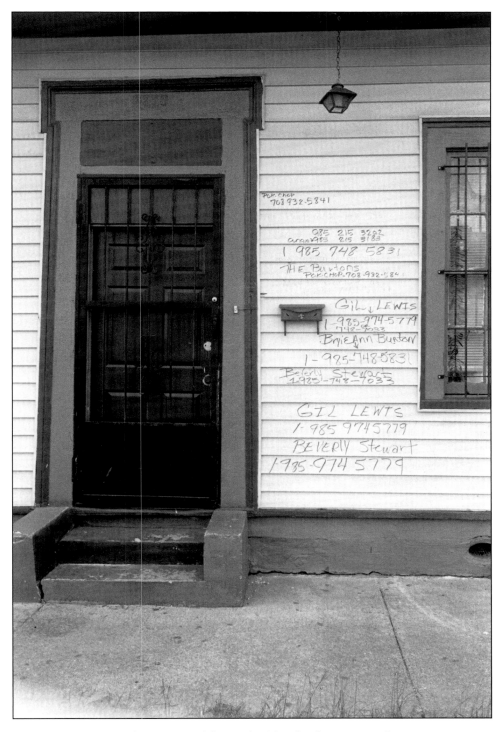

With people scattered far and wide, the front stoop became
a place for posting current phone numbers.

IV

A Very Long Road . . . Ahead

The mayor told us we are back and for those who hadn't come home to do so as everything is fine. Well, there still were entire neighborhoods dark, without power. There were thousands of cars abandoned, and streetlights were still nonfunctional. The streetcars were out of commission. Blocks and blocks of houses that had been flooded were waiting for owners or tenants to return and start the cleanup. We were probably half the population we were before the storm. Yet the mayor insisted that we were back and ready for business.

Uptown was ahead of the rest of the city because most of it was spared the curse of the floodwaters. The entire foundation of New Orleans, though, was destroyed or heavily damaged. Our public education system. The medical community. Our housing. Water and sewer systems. Our streets and mass-transit system. There seemed to be the attitude among some people that they were waiting for someone else to come in and fix everything. Anger and frustration were growing.

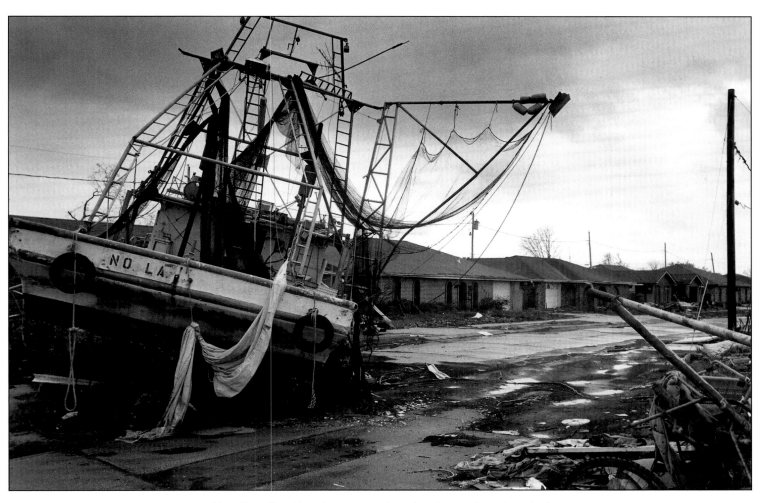

Months after the storm, a shrimp boat remains stranded
on a street in St. Bernard Parish.

To All:

Oh my, it is already December, what happened to September, October and November, just a string of days that seemed to never end.

Only if you read the paper cover to cover would you notice the article on page 13 today. The Governor of Miss points out that LA's money request has stunned the Feds. Miss has asked for 34 billion, which is a huge amount of money, and the great state of LA has asked for nothing less than 250 billion. Even me with my Okie math, I can figure out we're asking for almost 7.5 times what Miss has asked. Sure our damage might be more and I'm sure it is, but as the Gov of Miss points out, it appears that we are asking for everything plus the kitchen sink.

Two things come to the fore that bother me. First, why is the Gov of Miss pointing this out, plus it is tucked in on page 13 of our TP. Shouldn't it be the press bringing this to our attention? It sounds and feels like business as usual. We all feel the press is taking cheap shots at us but if we are trying to scam the Feds, shame on us. I'll share with you another example. I was talking with a Charity ER Dr., she shared with me and all who would listen that Charity suffered 27 broken windows, and some flooding in the basement. She was there and spoke to the building engineer. Now from what I've heard Charity said the building was a total loss, needs to be torn down and they needed 700 million to build a new hospital. Two very different views and I am sure the truth lies between the two, but my point is Charity is old and needs work, but trying to convince the Feds by shading, very heavily shading, the truth is awful. See I'm not calling it lying but most of you would. Second, if we are asking for pie-in-the-sky stuff, no wonder the flow of funds has stopped.

We deserve the rough treatment in the press. We need to get word to our elected officials to find a sharp, very sharp pencil and rework the numbers. Get real! Both the Gov and Mayor are telling everyone we are back and come home, this sort of stuff is going to slow that down, if not stop the rebuild of N.O. I've got a novel idea, tell the truth!

Hard to believe that the 9th Warders are now just getting to go home and look, can't stay, but have a look and try and find some personal stuff. Ninety-five days after Katrina they get to go home. I can't imagine, must be like living it all over again. I was down there the other day and it is almost unchanged from when the water was drained. Houses in the middle of the streets, cars upside down, concrete foundations are only what is left at many addresses. Military trucks moving through the area to keep the looters out. Looks and feels like a movie set, after the big WWII battles where towns were destroyed. The good news with cooler weather and the passage of time, the stink isn't very bad. Thousands of homes gone or almost gone, I can't even imagine where to begin the rebuilding. If you think the trash is a problem up here in Katrinaville, you won't be able to get your mind around what is going to be hauled out of there.

Was out in Kenner and you wouldn't believe the blue roofs out there. For some reason I didn't realize how much damage they got. Stuff piled high on the curbs, just like us over here, but their streetlights are working and most of their businesses are running. The fast-food world out there is moving slow, not enough workers. Wouldn't it be interesting if we saw a drop in the obesity and heart problems because we can't drive through and fill ourselves up with fried and biggie-sized whatever.

I saw another first, one house with two FEMA trailers, guess that guy is really rich. Out by the Coke plant they have built their own village, I guess for their workers. The things

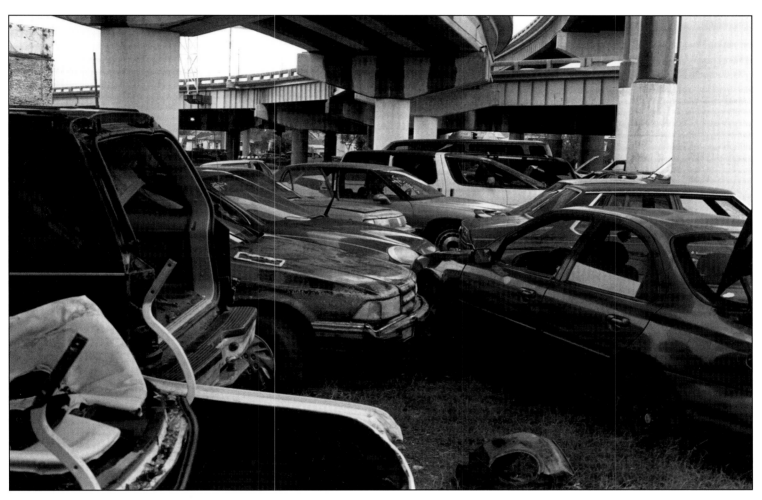

As the water receded, flooded and abandoned cars were hauled under
overpasses and to elevated parts of the interstate.

that are being done so they can stay in business and compete.

More later,
David

To All:

I got to spend some time with John S. the artist. John is in my mind the best and most important living artist in and from New Orleans. His work is extremely well done, not only in its art skill but also in its meaning and its representation of inspiration and passion. His art is an entire life flowing through him. He has been exiled to Houston and you can see his sadness and feel his longing to come home. His house and studio have been severely damaged by Katrina. His health has taken a beating, he is now using oxygen. Sitting and talking he told me that his work prior to the storm was very troubled, twisted and grotesque. It got so intense that he had to stop drawing. Then Katrina! He now says that the drawings were some sort of a premonition of the things that happened. Now he is stuck in Houston, with failing health. His eyes and conversation let me know how he longs to be back here working.

I told him of my work and what I had been doing, he is so supportive and interested, he has been a mentor to me for many years. I now need to go back and look again after hearing his story and lament, as I'm sure that will influence my sight. He keeps journals, in which he takes notes, makes notes, draws, sketches, works ideas for new pieces every day. There are over 120 of these journals and they are safe. They may be one of the best works on an artist's life I have ever seen or heard of. Each volume is a window into John's creative soul. Again I say he is one of our greatest talents and

spending time with him is a treat and honor.

I'm fighting trying to avoid becoming stale and bored with the recovery. It is creeping along at a snail's pace. Inches of progress but still progress nevertheless. The dark areas don't seem to be coming online. I heard a disturbing story, don't know if it is true but it does sound like it could be. After the storm when all the other energy companies came rushing into N.O. to help, working to light us back up, things were coming online pretty fast. Well, when Entergy filed Chapter 11, those companies packed up and headed back home. It was told to me that they all rushed here wanting to help but knowing that they will be paid for their work. With a Chapter 11 filing, they may not get their money or it will be a very long time coming. So the story goes, one of the main reasons why it is taking so long to relight the city of N.O. is the Chapter 11 filing and the withdrawal of all those other power companies. As I said, I don't know if it is true but it does make some sense, as I can't say I've seen many or any other power companies around town.

More later,
David

To All:

Sure we need Cat 5 levees but what we really need is some Cat 5 politicians! Someone who is deep rooted and able to withstand these hard winds and is able to direct the flow of our future.

Got to love the cooler weather, I'm hoping that it will kill most of the coffin flies. It does help getting in the Christmas mood.

Monday, I was with a group of folks touring, they were from a huge company that builds homes. Having seen earth-

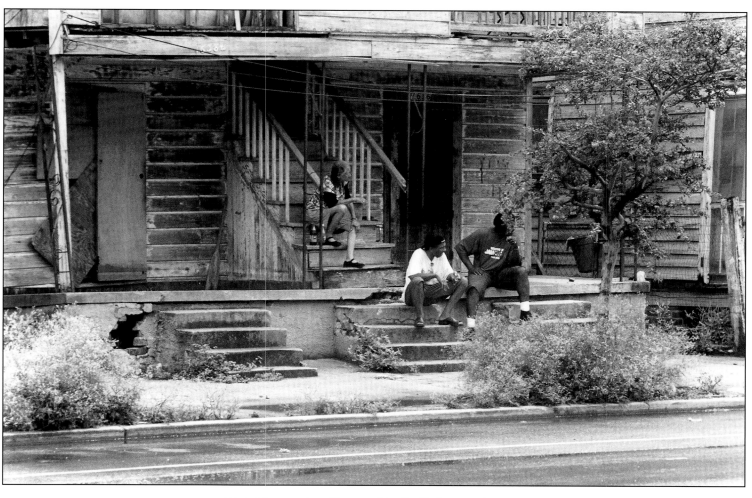

Watching and waiting on North Claiborne Avenue

quake and fire damage as well as lots of hurricane-damaged areas in Florida they were overwhelmed by what they saw. They are teaming up with an LA company and are planning to build thousands of houses.

While on tour with these folks as you turn every corner you see more sad stories. As time and some distance gives us a new perspective it also gives us a new insight into the sadness and destruction. The only people we saw while on tour was the Red Cross driving around trying to find hungry workers and there weren't any and some military patrols keeping an eye on things. Some of the grass is growing green, but these thousands of empty, broken houses standing or kneeling there alone, is heartbreaking. Cars on porches, houses floated together, boats in trees, it is the same old thing but yet it is new again. Realizing that it probably won't change much in the next 100 days or the next 100 either. Ruins of Pompeii come to mind. Life as we know it is gone, lives as they knew it are gone.

Was down in one of the high-rise office buildings, so many of the windows had been blown out, still glass everywhere, fifty floors up, missing windows, imagine those pieces of glass hitting the ground. Looking out over the city the entire place is dotted with blue roofs, as far as the eye could see.

More later,
David

SUBJ: Fri. 9.XII.05 Day 102

To All:

The first 100 days of Katrina have come and gone. Once upon a time you could pretty much tell how a U.S. President was going to do, by the first 100 days. Remember the great book about JFK's 100 Days? What is your verdict of our 100 days?

I'm worried that N.O. hasn't been very good this year and Santa may be giving us rotten potatoes in our stockings. It appears that we keep putting our worst foot forward. At a House hearing in Washington this week, several of our fringed, crazy, finest were there ranting about racism, great. Scaring those middle-American legislators to death, leaving them and all who viewed it with the impression that we are nuts and getting more so by the day. I was told that our wacko witnesses were there at the invite of Rep. Jefferson. Once again we come across as this freak show from "down yonder." I heard someone say we are the nation's "Whore," everyone loves coming down here, having their way with us, getting crazy, doing all the naughty things they can't do in their respectable home towns, leaving, denying that they would ever act that way. Plus never calling us in the morning. Loving us and leaving us, now they are holding us up as immoral and not worth saving. Just as no one steps forward to help the town whore or town drunk when they fall, no one seems willing to help us.

I'm also starting to think we are going to have to sink further down before the nation and congress will give us a leg up, certainly not a handout. I think we need some more bloodlettings, getting rid of some of our other scoundrels and remove some of our good-ol'-boy networks. I'm not saying the Feds or other states are much better than us but we have been playing a loose game of liar's poker and our hand has been called and we lost. All the good ideas and worthy projects are getting glossed over by these carnival shows that the Mayor calls town hall meetings, and the freakish congressional hearing that Jefferson calls, trying to pass off the invitees as representatives of our fair city.

Long waits continue at most restaurants, opening hours are still much shorter than normal for Christmastime here in Katrinaville. I'm still waiting for a visit from my insurance adjuster, progress comes in very small bits, if at all. Several

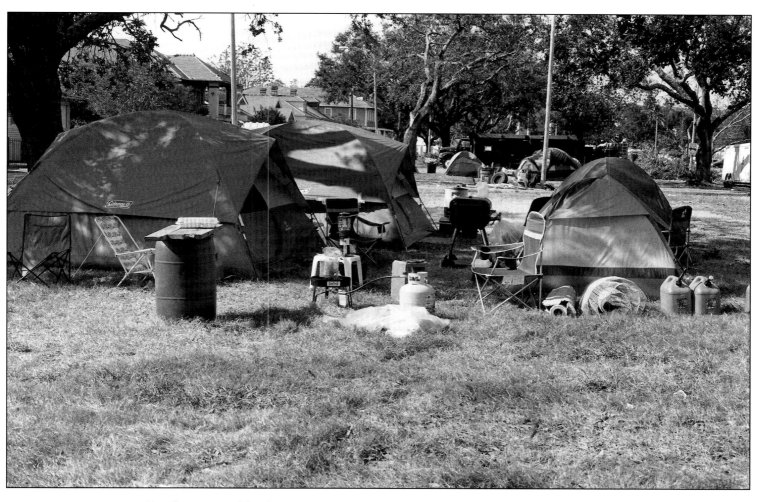

Worker camps like this one in City Park were filled with folks from across the
country who came to make a living by helping with the rebuilding.

coffee-table books have hit the stores about the storm and the aftermath. Being here but not seeing TV, the images are really amazing to me. My world was and is pretty small. I was also told that the looting might have been a lot worse if there wasn't so much flooding. Keeping the thugs out of areas and doing more damage. Now is that good or sad news? "Back to normal" is a long way off in my eyes!

As I ride around in the evening looking at Christmas lights, I can't help but be struck by the weird partnering of houses. A giant snow globe of Santa in a front yard, next to a house without a roof or totally dark due to no power. Sometimes behind huge piles of trash, sheetrock and torn-out studs, there will be Mary and Joseph waiting for the baby Jesus. Many of us have lots to be thankful for and there are many more who are still wandering and wondering what their future holds here for them. I've been in churches with torn-up carpets, boarded windows, tarpaulined roofs, yet I'm sure on Christmas Eve and Christmas Day these houses will be full of joy and thankfulness. Which is how it is supposed to be.

More later,
David

SUBJ: Mon 12.XII.05 Day 105

To All:

Seems like all the major newspapers are sporting editorials saying we are a dying city. Katrina may be the death of us. What I would like to point out is that we have been for many, many years a terminally ill city, attached by a life-support system to the Federal Government. Unable to live alone, on our own, always needing large infusions of money to keep us afloat. We have spent all those billions from our oil and gas. We don't know how to raise our young, teach our children or care for our sick. We stumble and falter with the simple everyday services that should be provided by our city government. Not to mention, as it appears to be, the criminal running of the levee boards. We plan for Mardi Gras, but fly by the seat of our pants when it comes to hurricanes.

The question needs to be asked, is this patient worth saving, as it was living before Katrina? My simple answer is no. Should N.O. be swept into the Gulf, no! We should do our very best to raise the bar, demand our politicians represent us in the best possible light, rid ourselves of the systems that have failed us, yes. Multiple levee boards, a school system that does nothing but consume money, a health-care system where when you have a headache you go to the ER. Has anyone noticed that our city runs just about the same minus the 50% reduction of its work force, this city government is bloated with political appointments. The list goes on and on, someone a lot smarter than me could sit down and write ten areas of reductions and we would be able to reduce costs and improve services all at the same time. We need to admit we are a city still attached to the Federal Gov. by an umbilical cord. Our long and short-term goal should be to wean ourselves off and get out of this position forever.

I've been reminding my photo agencies and anyone else who will listen that there are still lots of stories down here that need to be told. I get a big yawn most of the time. They are done with us for right now! Remember, I think I told you about a barber cutting hair in a Shell station. His shop was around the corner, flooded, yet with a generator he is cutting hair. Lots of relief workers and a few regulars that have found their way back home. I think that is a very good story yet none are interested. Go figure. All I've been hearing is contact someone, anyone in the Federal Government and get

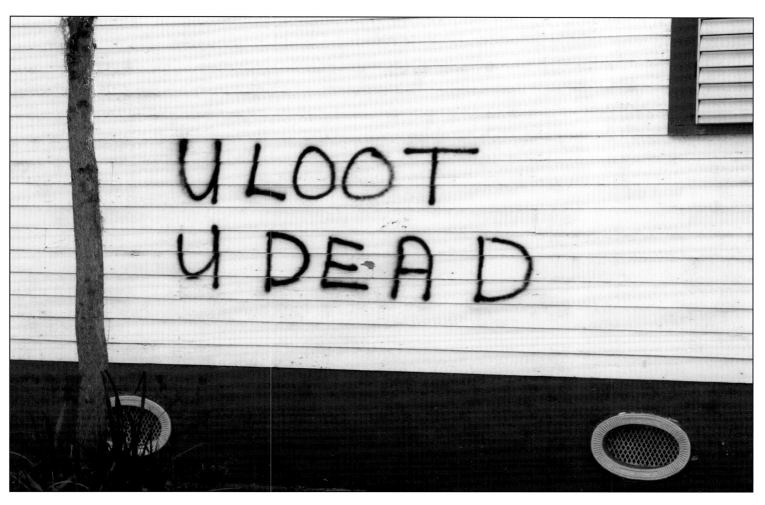

This message conveys an unmistakable warning.

them to fix us. I'm seeing lots of folks just giving up because the Feds aren't dumping truckloads of money on us. The pictures are going to get a lot bleaker before they get better. That really bothers me.

More later,
David

SUBJ: Wed 14.XII.05 Day 107

To All:

Ten shopping days until Christmas!

Today I was back in Lakeview, it feels like a movie set, all the props are in place. A few cars left at odd angles to add to the effect. The streets are swept clean but not a living soul for blocks and blocks. No rebuilding, just empty houses with doors ajar, broken windows. I was touring a client from the safety industry, their products are rebreathers and safety goggles, etc. These guys are in the destruction business, I was scared they were going to skin their jaws when they would drop as I showed them around. At one point, getting out of the car, one of the fellows says, well, this house doesn't look so bad, which it didn't at first appearance. Then I pointed out the waterline a good three feet above our heads, added that the water stood that high for almost thirty days. They both looked at each other and things got a lot more serious. We went into that house and both men were almost brought to tears by what they saw. All of a sudden they got it. Most do after spending some time in those areas, no matter how strong you might think you are, something that you see, a family picture, a table or chair that catches you off guard. Bam, it all becomes very real and personal. As we were driving we turned a corner and there was a house in the middle of the street, both those guys thought for a minute we had turned into a dead end, then they realized what they were

looking at, that house had floated there, more disbelief, more dropped jaws. As if that wasn't enough, I thought we found someone working on their house. Driving up and parking, I got out and introduced myself to this woman, she was behind a mask and glasses. Asked if it was her place, it was, but she didn't want to be photographed as it was all too much for her. She was throwing out all her personal stuff and was having a very hard time dealing with the loss. I felt that we were intruding, so we backed off very quickly, again my clients were almost overwhelmed by the scene.

Over a hundred days out and we aren't seeing any new leaders move to the front. The Gov has put off the elections. I'm not even sure if we dug up Winston Churchill he could fix this mess. I must quote Einstein again: "We cannot solve problems by using the same kind of thinking we used when we created them!"

So far the only one who has appeared to be making waves is Tulane's President Cowen. He seems to be facing the problems head on and making tough and hard decisions that will affect the University. Hopefully, restoring it and getting it up and running as soon as possible. Tulane is moving, moving forward fighting and working to get back on track, I like and admire that.

More later,
David

SUBJ: Fri. 16.XII.05 Day 109

To All:

Why is it when someone says something to the press no one ever checks the facts to verify if their statement is right or wrong? Let's look at some facts, numbers gathered from the TP. Of the first thousand victims that died during and because of the storm 41.7% were Black, 37.3% white and

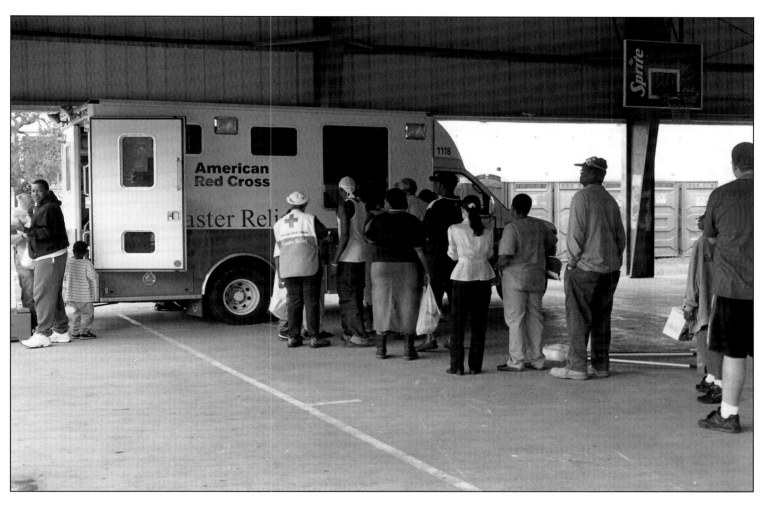

Breadlines formed from a cross section of New Orleanians.

17.5% unknown. Looks pretty even to me. Now let's take into consideration that the population mix before the storm was about 65% black and 35% white, so taking the number of dead and factoring in the population mix there was a greater percentage of whites who died because of Katrina. So where is the genocide and conspiracy? Where is the media, challenging these outrageous and irresponsible statements and accusations? In medicine everything is challenged and needs to be backed up with facts and data. Why in politics can you just say it and it is taken as true? These statements by our dear Mayor and others are fueling the race war that seems to be smoldering under all the Katrina debris.

More visits from returning folks, nice hearing their stories, better yet having them home. I do hope they realize the long road ahead. Several returning friends have told me of medical problems they had while away. I guess the stress and worry made itself known. One friend told me a very sad story of an old neighbor who was determined to ride out the storm. His story doesn't have a good ending. He was rescued from his house in Lakeview, with most of his clothing ripped off him by the raging waters, he lost his two beloved dogs. Ended up on a bridge or overpass, not thinking clearly, persuaded the police to drop him over in Terrytown at someone's home he knew. They had left, I was told he broke into a car and was living there and eating tuna fish from a can. Things got really bad and sad and he took his own life by hanging. A kind and nice old Lakeview man, his world destroyed, his life upside down and he decided it was time to go. My heart breaks each and every time I hear one of these stories. His sweet little world, great neighborhood, two dogs, comes to a shattering end, there alone in the heat in a car. There must be hundreds of folks who felt they could weather the storm, beat the odds, take care of their families. Katrina had other plans, the levees had other plans.

As a photographer I've come to realize that my images can't and don't even come close to expressing the depth of the sorrow and pain this community has experienced and will experience for years to come. Every time I go out shooting, I'm looking for the defining image that will express the pain but will let you see and feel the hope.

More later,
David

SUBJ: Tues. 20.XII.05 Day 113

To All:

Final approach into Christmas, I'm going to start shopping tomorrow, a day earlier than usual. Figuring to take the pressure off me since Katrina.

Getting positive sales reports from some of my neighbors here, which is exciting but also realizing that they didn't have any business in September, October and a good part of November. There seems to be a desire to shop locally and support each other. With the weird work schedules and shorter hours the traffic is nuts. Getting across town is a chore, the distracted drivers are out in full force. More folks are showing up and complaining that they are having to wait to eat and wait to get gas and wait on most everything else. Those of us who have been here for a while know the drill and we are adjusting our schedules. Today for example I had to go downtown and street parking was impossible, nothing was moving, workers and more workers and their trucks were making it hard to park. Extending my projected time downtown by more than an hour.

Talking with some of my medical friends, it appears some of the first returning workers to our fair city were the "ladies of the evening." Opportunity was knocking, all those soldiers, relief workers and construction workers. If you haven't been to the Quarter of late it is almost all male and a pretty

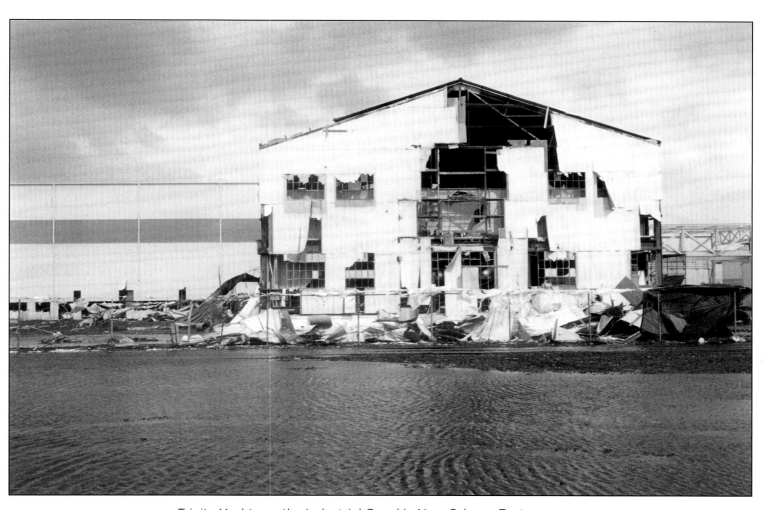

Trinity Yachts on the Industrial Canal in New Orleans East was once
the boatyard of Andrew Jackson Higgins, inventor of the landing craft
used in World War II.

rough bunch of men at that. Pockets full of money and looking for love. As a result of our free-enterprise system, well probably not so free, we are experiencing a huge increase in Socially Transmitted Diseases. We are no longer the murder capital but may be just behind some of those south of the border, border towns known for wild nights and one-night stands that have to be treated later after the hangover. Hope the Chamber of Commerce isn't gathering stats on this. Can't be good for the convention business.

It appears that some of the politicians are getting the message, we want it done right this time. We want to take back control of this community. We will welcome all those who want to come home and contribute. Not interested in having a bunch of takers, who aren't willing to be part of the well-being of this community. It also appears that some of the major newspapers are starting to report that Katrina wasn't only flooding poor black neighborhoods. It has only taken them three months to stop listening to Jesse Jackson and start looking with their own eyes and looking at the facts. So I'm figuring at this rate it will take almost a year to get the truth out about how deep our troubles go.

It is still very strange to drive around town and see some houses loaded with Christmas lights and others still boarded shut, still others on the same block piled high with debris. We are and will be for a very long time a study in contrasts. Just as we are a study in different cultures, we will probably survive because of our differences. I'm comfortable with having Mardi Gras, as I see it as much more than just a bunch of drunks in the French Quarter. Think about all the little kids on shoulders and ladders. It is celebrated across the area, not just in Orleans. It certainly isn't the end all, but it is part of us and should be here as without it we are just another American city. My point here is that if we can pull off Mardi Gras we should be able to pull off elections. There may be a

shift in power, that may not be a bad thing. The last quarter of a century hasn't been our finest, you know the stats and problems, we are due, overdue for a change. So let's push for elections, it is time to move the process forward.

More later,
David

SUBJ: Fri. 23.XII.05 Day 116

To All:

The traffic is starting to ease, people are slipping out heading home or wherever. Christmas is here. All reports are that Christmas has been good for our shops. That's a good thing.

The fly in the ointment is that Wonderful Bill Jefferson has gotten permission to place FEMA trailers on all those cleared housing projects locations. We battled for years to rid the city of these crime-creating, drug-dealing areas and now Mr. Jefferson is going to load them up with trailers, instant low-rent housing. I've yet to hear how long people will be allowed to live in them. What kind of requirements are going to be made for taking care of them. It sure doesn't seem to be a good short-term solution.

Another concern I have is how is Santa going to land on these blue roofs. I'm worried for the reindeer, traction can't be good, plus so many of the chimneys have been blown off. Mr. Claus could get stuck. With all the displaced folks, my concern is how will he get all the gifts to the right places. Lots of the landmarks are gone, flyways are altered. Santa is going to have it rough. But no doubt my rotten potatoes and coal will find their way to me as they always have.

One really nice thing is I've seen and heard some wonderful holiday wishes and greetings. I do think Katrina has

A neighborhood barber who lost his shop around the corner
resumes business at a defunct gas station on Claiborne and Napoleon,
using a generator for power.

made us all stop and take stock. So many have died, lots have moved and many more are dealing with so much uncertainty. So here we are still standing and we are so glad to see friends and be with them. It is really an important part of the season and this year it seems to be hitting home! We have been through so much and shared Katrina in so many ways. The hugs and kisses seem to be really heartfelt. With holiday wishes, Merry Christmas.

More later,
David

SUBJ: Tues. 27.XII.05 Day 120

To All:

A special Christmas to be sure. Thoughtful and meaningful gifts. A quiet holiday, one with reflection and deeper meaning as we work our way out of this quagmire.

Made a driving tour of the Slidell area yesterday afternoon, brilliant sun and great weather but the total devastation of the area even four months out is shocking. Cars, boats, large bits of houses and other unrecognizable debris litter the marshes. Pilings are all that remain where camps and houses used to be. Scraped earth appears to be the future and then maybe rebuilding will begin.

As the end of the year approaches I remember arriving in N.O. thirty-three years ago. The Dome was just being built, the steel understructure was being assembled. All the talk was how that building was going to change this city. Well, it did in many ways and I was on the ground floor of an old southern city moving forward. Then in 1984 the World's Fair was going to fling us further along, in many ways it did, without it the convention center would have never happened. Again I was here hoping that a rising tide would float all boats. Now in 2005 Katrina has reset the clock, in 2006 will I again be part of a rebirth of this city? This time will we get it right or will we limp along again? With those two first city-changing events, the Dome and World's Fair, we never lived up to our potential. So my hope is that the third time is the charm and we will fully realize the opportunity and grab it and make those hard and important decisions. If we slip back into our bad habits, and we all know them, we will continue to spiral down. No one wants that but that is my biggest fear as this year comes to an end.

We are all waiting, as we have been told January is going to be the bellwether mark as to our recovery. Droves coming back, businesses reopening, schools filling with children, hospitals coming online. Are we expecting a knight on a white horse, better yet the man from FEMA with a magic wand and a huge bag of money, coming with a plan to make us all whole again, while raising the levees above where they were? My sense of the situation is that this rebuild is going to take most of the rest of my life. We need to understand and grasp it. As much as I would like to see a knight or FEMA man, I don't think they will appear in January. The year 2006 will be the start of our biggest challenge yet, let's ready ourselves for the task!

More later,
David

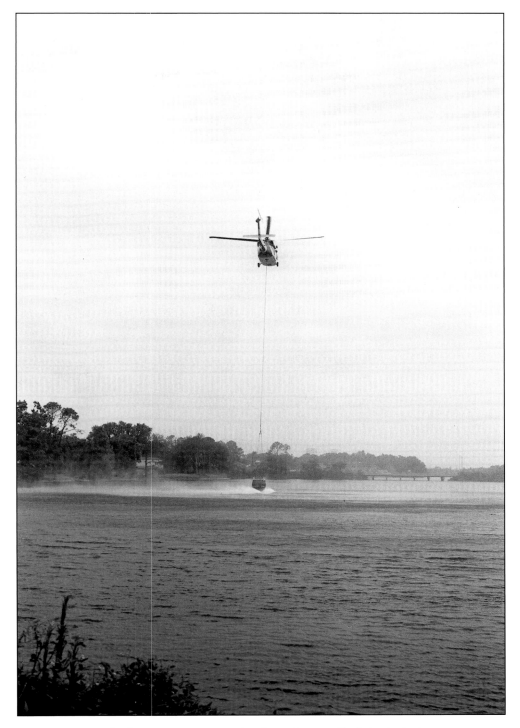

A helicopter scoops water from Bayou St. John to help
fight fires in the Gentilly area.

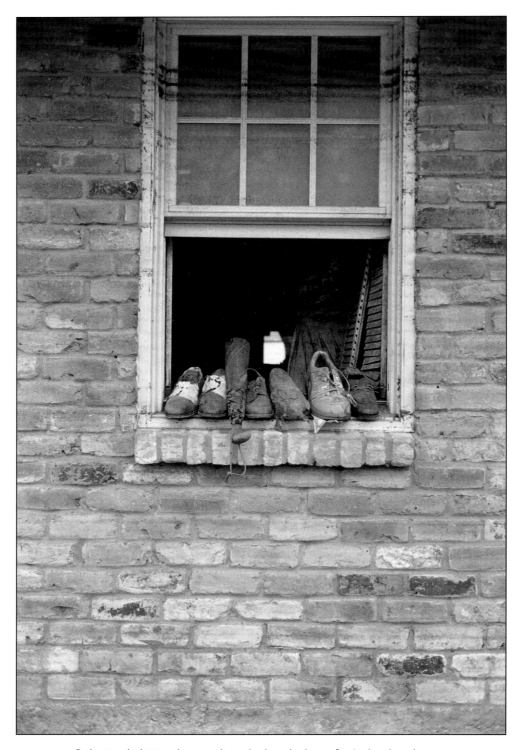

Salvaged shoes dry on the window ledge of a Lakeview home.

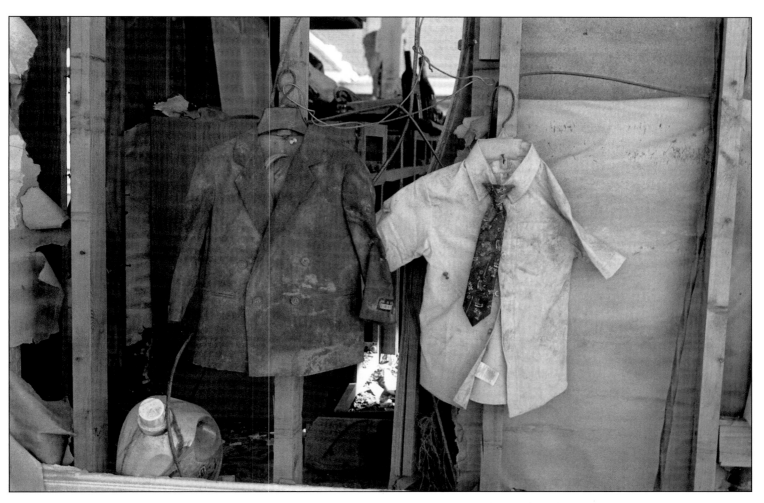

My petty grievances about lacking starched shirts are shamed at the sight
of these clothes in a Lakeview residence.

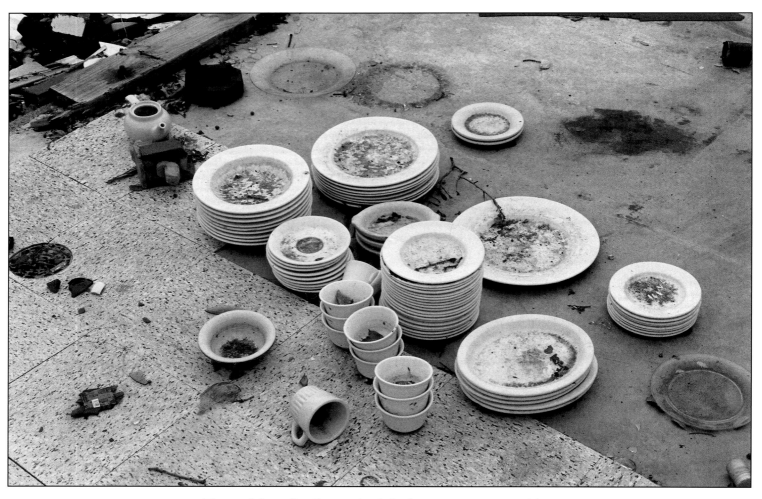

These dishes silently speak of the hope to save something,
anything, from life before the storm.

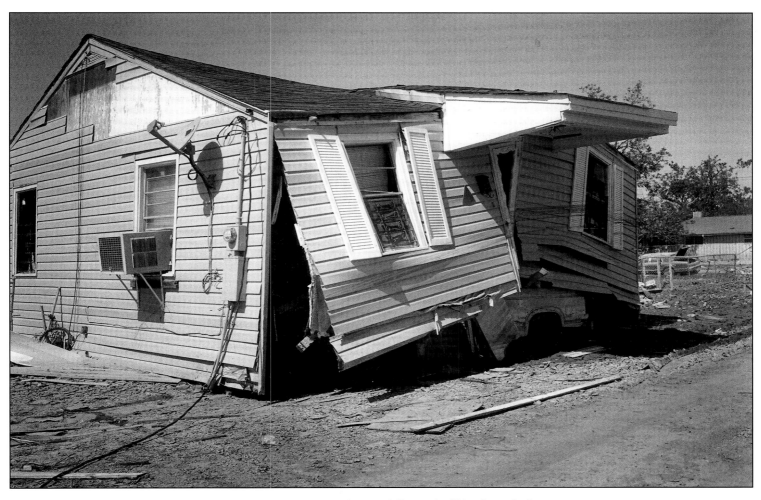

This house in the Ninth Ward floated off its foundation
and came to rest on a car.

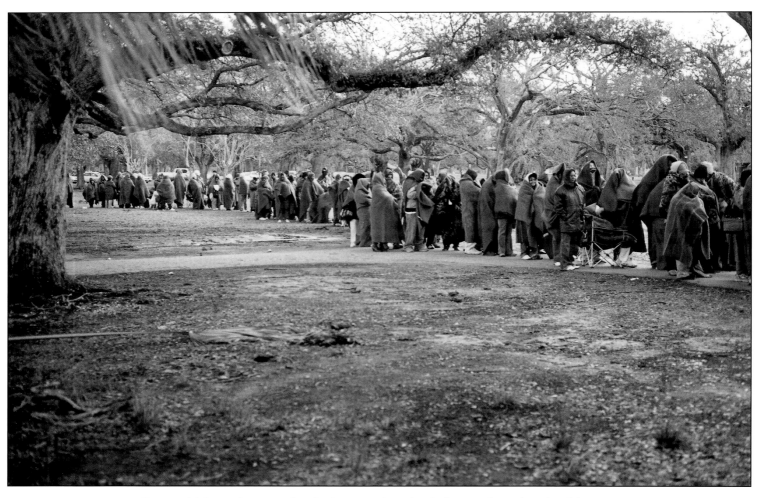

On a cold Saturday morning in January, hundreds line up for a free health exam
in Audubon Park, wrapped in wool blankets donated by Russia.

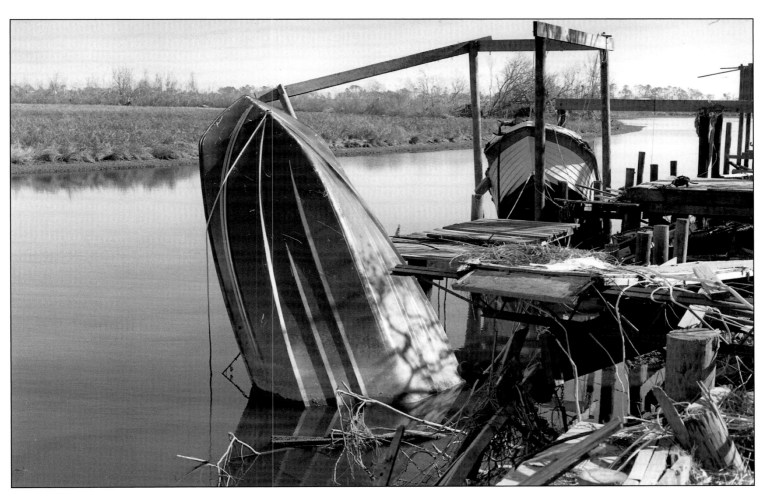

A boat at a Slidell dock resembles a whale jumping from the water.

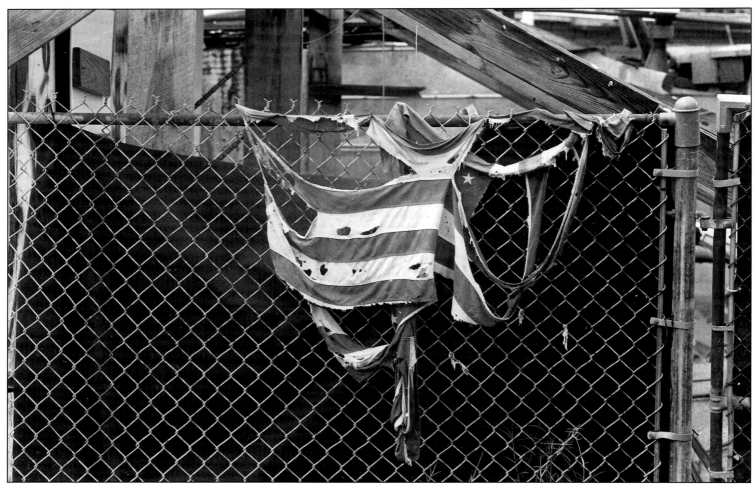

In the Eighth Ward, a torn and tattered American flag
reflects hope and despair.

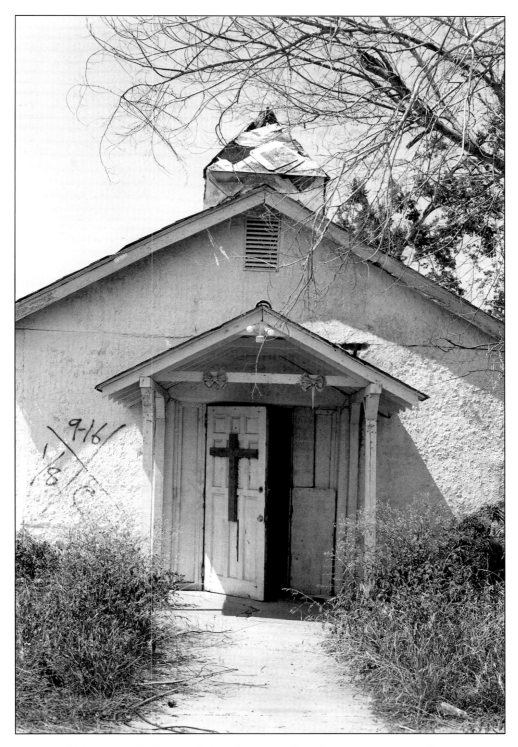

This small Ninth Ward church awaits its returning congregation.

Afterword

This work reflects my personal views and feelings on a huge, life-altering event. I am so very much aware that my perspective was limited by so many obstacles. The damage to my life and property was nothing compared to what many others suffered.

Lessons learned have been various and many. I, for one, was tested and challenged in a way I had never been tested before. My father was in World War II, and many of my friends were in Vietnam. Staying and dealing with the trials and tribulations after Katrina was my test. Not only as a person but more important as a photographer. I have spent my life studying the great photographers and their work during wars, depressions, and great political and social strife. Katrina thrust me into a historic and tragic moment. I've tried to be respectful and honest, to offer something different from what the media presented. A view from an adopted son who cares deeply for his city and region.

My comments about political leaders and events are mine, and I stand by them, realizing, of course, I might not have had all the facts and that our leaders were under tremendous pressure. Having acknowledged that, I remain disappointed in the lack of leadership. At times of crisis, leaders usually come to the forefront. I'm still waiting. We still need a battle commander who is willing to make the tough decisions. Decisions that will anger some but in the long run will be for the greater good of New Orleans.

We are all painfully aware of the big picture of devastation and suffering, but I have tried to show how little, simple things and small ways of life were affected. So much has been documented and will continue to be. I hope my effort will contribute to an ever-expanding understanding of Katrina.

More later,
David G. Spielman
29.VIII.06